Daniela Bowker

Social
PHOTOGRAPHY

MAKE ALL YOUR SMARTPHONE PHOTOS
ONE IN A BILLION

ILEX

First published in the UK in 2014 by:

I L E X
210 High Street
Lewes
East Sussex
BN7 2NS
www.ilex-press.com

Distributed worldwide (except North America)
by Thames & Hudson Ltd., 181A High Holborn,
London WC1V 7QX, United Kingdom

Distributed in the US and Canada by
Ingram Publisher Services

Publisher: Alastair Campbell
Associate Publisher: Adam Juniper
Executive Publisher: Roly Allen
Managing Editors: Natalia Price-Cabrera & Nick Jones
Specialist Editor: Frank Gallaugher
Editorial Assistant: Rachel Silverlight
Creative Director: James Hollywell
Art Director: Julie Weir
Design: Kate Haynes
Colour Origination: Ivy Press Reprographics

British Library Cataloguing-in-Publication Data
A catalogue record for this book is available from
the British Library.

ISBN: 978-1-78157-981-7

Printed and bound in China

10 9 8 7 6 5 4 3 2 1

CONTENTS

Introduction

I started taking photos in 1985. I was five years old and it was an exercise in patience. It wasn't just the patience needed to compose my shot and make sure it was right, because I didn't have more than 36 exposures on my roll of film, but it was the patience needed to wait for the film to be processed and for me to be able to see my photos. And then I'd need to wait for my friends to visit me, or for break time at school, to show them glimpses of my world on photographic paper.

It's a bit different now. I can pull my phone out of my pocket, take a photo, make some swift edits, and within seconds I can share my here and now with people whose heres and nows might be worlds away from mine.

In the space of a few decades, the way that we take, look at, and use photos has changed enormously. Photography doesn't have to be time-consuming, technical, or expensive anymore. Instead, it's immediate, inexpensive, and it's exciting. Between the smartphone and the smartphone photograph, we've changed the way that we take and use photos, and we've changed the way that we communicate. Images are instant and they're social. You see exotic holiday photos on Facebook; share your breakfast on Instagram; the amazing window display you just saw is on Twitter; and there's a fashion shoot on Flickr.

There are an awful lot of photos in this Technicolor world of ours and a huge number of ways to share them. So how do you get the best social interaction out of your photos and the best photos from your social life? Where do you even start? You start here.

THERE ARE
an awful lot of
PHOTOS
IN THIS
TECHNICOLOR
WORLD OF OURS
AND A
HUGE NUMBER
OF WAYS TO
share them

WHERE
DO YOU EVEN
Start?

YOU
START
here!

Quick Start

THE
SOCIAL
BASICS
IN Just 2 PAGES

DOWNLOAD IT

1 Which social network are you going for? Twitter? Facebook? Instagram? Google+? Flickr? All of them? Download the app!

CREATE PROFILES

2 Create your profile—set up your profile so that people know who you are.

TAKE A PHOTO

Shoot a photo or pick a picture from your camera roll.

STYLE IT

Give it a look that's unmistakably you.

SHARE IT

5

Unleash it on the world!

Cloud computing, cloud storage, cloud sharing. Gone are the days when data was stored on floppy disks and photos were taken on film and printed on paper. Now we upload and download at will, wherever we are. Where it's at now is in the ether.

Life

IN THE

Cloud

Smart PHONEOGRAPHY

When Apple announced its iPhone in 2007, it was one of those moments the tech industry refers to paeanically as "disruptive." Yes, it was a phone, and you could still use it to make calls, but it was much more than that. It was as if everything that we had ever known about telephones and the internet and cameras and sharing and communicating had been thrown into a blender, and something iconic emerged. The iPhone was set to change irrevocably—or "disrupt"—the way that we communicate.

We'd been able to access emails from our phones for a while, and taking photos with your phone wasn't anything new. But now everything was different. Suddenly, there was an internet-ready computer in your pocket, and these things called "apps." Within a few years, we'd see the rise of billion-dollar image-sharing start-ups, the near-collapse of the compact camera industry, and a complete shake-up in the way that we share information. It was definitely disruptive.

With the ability for you to take a photo on the go, with a camera you would always have with you; for other people to develop stand-alone applications that you could use to share your images with different people, in different places, in different ways; and being able to see other people's photos when you were sipping coffee, or sitting on the train, or away on holiday—things changed.

Now, hundreds of thousands, maybe even millions of photos are taken with smartphones every day, shared across a plethora of platforms, and viewed on all sorts of devices. Where Apple led the way, a great many manufacturers followed. Smartphones are ubiquitous, and so is smartphoneography!

The little device that changed everything about the way we communicate. #IPHONE

Taking a photo
WASN'T ABOUT
MAKING
A MEMORY FROM A
Party
OR
Holiday
ANYMORE

IT WAS ABOUT THE
ABILITY TO
communicate
IN PICTORIAL FORM
RIGHT THERE & THEN

IT WAS THE START OF
iPhoneography

Light through glass. #IPHONE (© Haje Jan Kamps)

The best camera
IS THE ONE YOU HAVE WITH YOU

Social NETWORKING

To be fair to our ancestors, social networking isn't exactly a new-fangled phenomenon belonging solely to the bright young hipsters. No one in Ancient Rome lived in isolation after all! It's more that the internet has made it easier for people to connect: you don't have to wait for your letters of introduction to cross the Atlantic by sea or learn how to dance a Lady Shaftesbury anymore. Now it's down to Web 2.0, and all about generating your own content and sharing on the internet.

When you micro-blog a statement on Twitter, upload a photo to Flickr, update your status on Facebook, or share a link on Google+, you're generating your own content, and people being able to share it onward or tell you what they think of it is all part of the interaction that makes it social. These so-called "social networks" are just places to meet new people and catch up with those you know already, not so different from a 17th-century coffee house really. Except with photos.

Social networking is definitely about the photos too. Every network makes it easy to share images, whether by choosing

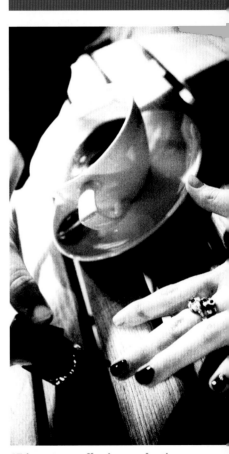

17th-century coffee houses for the digital age. (© Frank Gallaugher)

a photo from your smartphone's camera roll or taking one straight in the app.

The global reach and proliferation of social networks can make signing up and getting involved a little daunting, though. What you need to remember is that you don't need to be a trend-setter, and you don't have to commit yourself exclusively to one network at the expense of the rest. It's about being where your family is, where your friends are, and where the people you want to hang out with hang out. You can be as promiscuous as you like with your social networks, and to get the most out of them you probably should be.

You'll likely find that you're connected to or followed by different types of people on different networks. That's just as it should be. You don't see the same people at home as when you go to work, as at your yoga class, or as at your book club: Social networks work similarly. As a consequence, you'll probably not want to share the same photo across all of your networks, but it's not hard to figure out what belongs where. And when things are meant to be cross-posted, it's normally fairly easy to share from Flickr to Twitter or Instagram to Facebook!

NETWORK
promiscuity

Don't feel you have to save your loyalty for just one social network. As different platforms attract different types of users, the more you join the greater your potential reach will be. Try not to get carried away though, especially when you're just starting out. Keeping all your social networks up to date can be a full-time job!

Connect with people all over the world through social networking.

Facebook

When it comes to social networking, Facebook is the alpha network. It has an estimated 1.1 billion active monthly users (although some of those accounts will belong to cats and spammers, so it's a little lower in reality) and roughly 3,000 photos are uploaded to it every minute. That's about six billion photos a month. Or, if you want to give that factoid a slightly different slant, almost one image for every person alive on the planet is posted on Facebook every month.

Of course, these photos are likely going to range from your Great Auntie Betty's seemingly interminable holiday snaps that she took on her Mediterranean cruise to the occasional upload from professional photographers using the network to showcase their work, with everything else in between.

For most people, Facebook is about staying connected. It's about allowing your family and friends—and that one random follower we all seem to have—to know what you're up to and where. But it's also more than that: Facebook is about building a collective memory. With the ability to share, like, and comment on

With so many photos being uploaded, shared, and liked across Facebook, if you want yours to get noticed and not drift off into a sea of pixelated has-beens, they really have to stand out from the crowd.

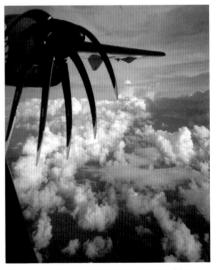

Up, up and away. #MEMORY #FACEBOOK

(© Haje Jan Kamps)

thousands of photographs, it is the new, upgraded version of the family album.

Facebook photos are snapshots of what's happening right now in your world, mixed with a repository of significant memories: birthday parties, holidays, weddings, and children growing up. They're the now and the yesterday all jumbled up, saved for tomorrow, and meant for you and everyone you know.

FACEBOOK
camera

If you're serious about Facebook and photos, and you use an iPhone, download the Facebook Camera app. With it you can take, edit, and upload photos to your stream, and go straight into the photo streams of your friends. It's Facebook, filtered for photos. Android users there's the externally-developed Bright Camera for Facebook.

FACEBOOK AT A GLANCE

WHAT TO SHARE?
Think of it as being like an online, publicly accessible photo album: holidays, events, and the children growing up

CROSS-POSTING
No: With Facebook you can only share photos within the network

LINGUA FRANCA
Like If you like a friend's photo you can endorse it, and bring to the attention of your followers, with a "like"
Newsfeed Your friends' activity
Timeline Your Facebook activity

LOCATION, LOCATION, LOCATION
Add a location to a photo, to remind you and show everyone else, where it was taken

Crop!

Style!

Share!

Pecking around in the garden

PRIVACY
Select your photo's audience from the drop-down menu

PEOPLE
Tag people who appear in your photos

Twitter

Twitter lives in the moment. It's instant news, instant thoughts, and instant sharing. Anything from five minutes ago is already ancient history on Twitter!

If you want to make your followers envious of the view from your hotel balcony in Zanzibar, or share an "I can't believe I've just seen this!" moment of Olympic proportions with them, there's no better place to do it than Twitter.

Who are your Twitter followers, though? I'll bet they're a motley crew comprising family and friends, friends-of-friends and acquaintances, professional connections, and people with whom you share common interests or mutual associations.

As well as the people you "know of" but don't necessarily "know" there will be people you've never met before and aren't even likely to. Chances are they have found and followed you because you have something in common. If they're still following you a couple of months down the line it's probably because they find what you have to say about life, the universe, and everything, interesting. They might happen to like your photos, too.

Now consider that Twitter is a broadcast medium. Unless your account is private, anyone can see and share your tweets. This makes your potential audience enormous, especially if you can capture a moment and ride a wave of retweets.

Whenever you go to tweet a photo, keep in mind who is following you and why they are doing so. Do you really want the whole world knowing what color your undies are today, and is the rest of the world all that interested? It might bring international, if fleeting stardom, but it's probably for the wrong reasons.

The photos that succeed on Twitter do so because of their immediacy. They might be personal, they might be of international significance, they might provoke a visceral response, but they will all speak of the here and the now.

THE
hashtag

A picture might be worth a thousand words, but a little hashtag help to categorize your tweets never goes amiss. If you're a bit mystified by the hashtag, think of it as a filing system: by adding a hashtag to your tweets, you highlight what they're about and help people who are searching for that sort of content to find them.

Say you took an Instagram photo of the cyclists whizzing past you on a stage of the Tour de France, you might add the hashtags #Instagram and #TourdeFrance to your tweet. Just be careful not to spam with hashtags—two is fine, three might be pushing it—and keep them relevant to the topic.

TWITTER AT A GLANCE

WHAT TO SHARE?

Twitter is the perfect medium for broadcasting what's happening right now, or for getting people to take notice of photos that you're particularly proud of

CROSS-POSTING

If you take a photo using the Twitter camera, you can't share it directly from the app with any other network, but that's not really a problem. You're more likely to be using Twitter to draw attention to photos that you've posted somewhere else, say Flickr or Instagram, or the nature of the photo means it's prime Twitter-sharing material

LINGUA FRANCA

Hashtag (#) Twitter's self-categorization system. Use it to mark key words or topics in your tweets
Retweet When you forward someone else's tweet to your followers
Tweet A communiqué via Twitter, limited to 140 characters

LOCATION, LOCATION, LOCATION

Let everyone know where you are by enabling the location settings when you tweet

PRIVACY

Whatever you share on Twitter is shared with all of your followers. Unless your account is protected, your posts can be seen and retweeted by anyone

PEOPLE

Highlight people in your photo by mentioning them in your tweet using the @ symbol before their handle, for example "@JoeBloggs"

Flickr

IF YOU WANT *your images* TO DO THE TALKING THEN FLICKR *is the place* TO BE

A book focused on social media might seem like an odd place for a history lesson, but indulge me for 30 seconds. At the time of the industrial revolution, a peculiar phenomenon occurred where the pioneers of development fell behind the curve and weren't able to compete with second and third generation entrepreneurs and inventors. Like most things, it didn't happen for just one reason, but the basic principle was that when their initial ideas were redesigned and improved, they didn't have the capital, or the foresight, or the will to upgrade. They were left behind.

When you look at social networks, you begin to see a pattern emerging. The first networks fell away to second- and third-generation sites that took what they did and made it better. This encapsulates Flickr's story. In the great history of social media, photo-sharing site Flickr is regarded as one of the first social networks. But even when the present and the future of social media lay in images—Flickr's natural currency—it failed to evolve its website and relied on a woeful mobile site. A pitiful fall from grace was looking inevitable.

Thankfully for Flickr and its legion of dedicated photographically oriented users, someone launched a major overhaul program before it sank into oblivion. The Flickr app now has its own camera function, editing buttons, and an array of filters. The website is a riot of color that's dedicated to images.

Flickr's emphasis was and is on photos, so on this network it's the photos that come first. Flickr puts the social into photography, rather than the photography into the social.

Flickr's for the photos you're most proud of. #FLICKR #FLOWERS #PROUD

FLICKR AT A GLANCE

WHAT TO SHARE?

Photos that you love and that you think other people will love too

LINGUA FRANCA

Favorite Like someone's photo on Flickr? You can "favorite" it

Photostream All your photos

Set Organize your images into groups, for example, "Italy 2013" or "Portraits"

Tag Add keywords to your photos to help people search for them

CROSS-POSTING

Sharing photos from Flickr is as easy as pie. When you're uploading an image, you can tap on the Facebook, Twitter, or Tumblr icons to share it there immediately, or send it as an email. You can do the same with an already-uploaded photo straight from the app

LOCATION, LOCATION, LOCATION

Yep! Flickr will geo-locate your photos for you and pin them to your world map

PRIVACY

Tap on "Public" and you can choose who gets to see your images

PEOPLE

Tap on "Advanced" and you can label people in your photos

You might be forgiven for thinking that Google+ is Facebook's weedier cousin who is always hanging around, but no one really knows what to say to him or what he likes. As it happens, he really likes photos.

One major plus point for Google+ is that it has a terrific image interface, whether you're using the desktop or the mobile version. You can share images straight to a post, telling people where you are, what you're doing, and who you've seen; or you can save your photos to albums for posterity (and sharing, too).

Better still, it's easy to target who does and doesn't get to see your photos. You can share them globally, with specific circles of friends, or with individuals.

If you're not confident editing your images to help them look their best (although we do cover this in Chapter 3, so by the end of the book you should be a pro), Google+ has the option to apply its auto-enhance algorithms to your photos. This will tweak the brightness, contrast, saturation, noise, and a few other elements in your photos to get them looking as good as they can.

TOP FEATURES OF *Google+*

You can back up your smartphone images to Google+ at the touch of a button. If you're not sure that Google+ is for you, it's worth it for that feature alone. Once uploaded, whether by auto-import or as an individual post, all of your images are organized into a timeline that makes it easy to keep track of your portfolio. There's also a nifty "highlights" feature that identifies your "best" images, or the ones that you're most likely to want to share, and curates them privately but ready to unveil to your followers.

GOOGLE+ AT A GLANCE

WHAT TO SHARE?
Treat it like an online album, with photos of things you've done and things you've seen

CROSS-POSTING
No: Google+ likes to keep things in-house

LINGUA FRANCA
+1 This is your way of endorsing a photo or a post

Circle A means of grouping together different people you follow. Think "family," "work," or "football"

LOCATION, LOCATION, LOCATION
Hit the "Location" button in the upload process and your image will be automatically geotagged

Crop!

Style!

Share!

PRIVACY
Select who gets to see your photos from the "To" box when you go to share

PEOPLE
Label people in your photos when you've uploaded them

Instagram

If photography as a social medium could be distilled into one app, that app would be Instagram. You take a picture, you apply a filter, and you share it with your followers. That's it. Where you are, what you're doing, and whom you're with conveyed in a Polaroid-lookalike instant.

How did it manage to grow from zero to hero in months? Because it's simple to use and exploited the iPhone's potential to its fullest: camera + mobile internet means instant updating.

Instagram's meteoric rise hasn't been without controversy, however. The Android platform saw some iOS users flounce off in a huff; the Facebook sale upset yet more people a week later; but the worst was to come in December 2012, when plans to amend the app's terms of service were announced. A careful reading of the terms indicated that Instagram expected you to license your photos so that it could sell them on to interested parties without you even knowing. The backlash was so severe that the company was forced to renege.

This is an important lesson for anyone who practices social photography: always read licenses carefully. You should aim to keep as much control of your images as you can. Don't let other people profit from your creativity!

THE INSTAGRAM STORY
in an instant

EARLY 2010: founders Mike Krieger and Kevin Systrom were working on Burbn, a Foursquare-like check-in app. They noticed that people were sharing images through it, rather than checking in. **MID 2010**: The pair pivot the app from check-in to photography. **OCTOBER 2010**: Instagram launches. It's a bit like Hipstamatic, but with the social element thrown in. **DECEMBER 2010**: One million users. (Yes, in three months!) **SEPTEMBER 2011**: 10 million users (and the app is still iOS-only and the company has six employees)! **APRIL 2012 I**: The Android version launches and 1 million people sign up for it within 24 hours. **APRIL 2012 II**: Facebook splashes out a whopping $1 billion for Instagram.

INSTAGRAM AT A GLANCE

WHAT TO SHARE?
When you see something that you want to share and only a photo will do, Instagram's your network

LINGUA FRANCA
Explore Instagram's search feature, where you can look for people or themes you're interested in
Hashtag (#) Instagram's categorization system, so that you can highlight your photos' subjects making them easier to find

LOCATION, LOCATION, LOCATION
You can pin your photos to your map!

PRIVACY
By default, Instagram shares your photos publicly. You can set your account so that only approved followers can see what you post

PEOPLE
Tag people in your photos by tapping "Add People" on the "Share" page

CROSS-POSTING
As you upload to Instagram, you can share to Facebook, Twitter, Tumblr, Flickr, Foursquare, and by email simultaneously

Crop!

Share!

Style!

Tumblr: Photos are about telling stories. It isn't just that one picture is worth the proverbial 1,000 words, but that strung together, a series of images can tell the story of your day, your week, or even your whole year. If you want to tell your story through pictures, and want it to flow uninterrupted by status updates and links to interesting but unrelated articles, consider Tumblr. Essentially it's a blog, letting you upload just about any kind of content you want, but its visual focus and the ease with which it allows you to share and update makes it perfect for the social photographer. You can cross-post from your other networks or upload via app, email, or straight to it. Much like Twitter makes it easy for people to retweet your tweets, Tumblr makes it easy for you to let people share and pass on—but hopefully not to pass off—your work.

In fact it's the social side of this platform that makes Tumblr unique in the blogosphere. Updates from blogs you follow will appear in a live stream on your homepage, which you can "like" or comment on, and tags make it easy for you to find the kind of blogs and posts you're interested in—and likewise for other users to find your content. So in some ways Tumblr is like a traditional blog crossed with Twitter, plus a few elements of Facebook added to the mix.

Once you've created a blog on Tumblr it couldn't be easier to post on the go. Choose your photo and share to Tumblr, then add a few words about it. Don't forget to add a few tags so that others will be able to find it!

Pinterest: Even if you don't use Pinterest, it isn't beyond the realms of possibility that one or some of your photos might make their way onto the site. Pinterest is, in essence, an infinite, universally accessible pin-board. When people see your photo of the Ballaro market in Palermo on Flickr and think "I have to go there!" they can pin it to their Holiday Plans board. Someone who has been rendered drooling and green with envy by your triple-layered hazelnut-raspberry-meringue cake that you shared on Instagram can pin it to his Must Try Recipes board.

For photographers it's a great way to gather inspiration, whether generally, or to help plan a specific project. Pins from users and boards you follow will appear in a live stream on your home page, and you can repin content to your own boards so that you'll always be able to find it. You can also add your own content. Download the app and you can upload straight from your phone, and use your boards to organize your photos however you like, for example by genre, by theme, or by date. Because pins retain their source, if someone repins your

photograph, anyone who follows the board it's pinned to will also be able to find you.

You can upload photos to Pinterest straight from your phone. Once you've downloaded the app, select the picture to upload to Pinterest, then share it to one of the boards you've already made, or create a new board.

A WORD OF *warning*

Although the sharing functions on Tumblr and Pinterest can lead to your work being seen by a much wider audience, both sites have come under fire for unscrupulous sharing practices. This might mean people passing off your work as their own, or sharing without permission or without crediting you. Unfortunately there is a possibility of this happening whether you use the sites or not. Both networks will remove content illicitly shared if you get in touch with them, but of course that relies on you finding it first. If you're concerned about this you might want to consider watermarking your work, which you can do with an app like Marksta (see page 155).

your
PROFILE

Very definitely not me!

I'm proud of my book, and it has my name on the front, but it isn't me.

Daniela Bowker
@SmallAperture

Author of books; taker of photos; baker of cakes. Previously disillusioned secondary school teacher, now editor of Photocritic. Cynical and hyperbolic.
Nominally London
about.me/daniela.bowker

When people search for me on Twitter, this is what they'll see. #PROFILE

When someone you don't recognize starts to follow you on Twitter or Instagram, or connects with you on Facebook or Google+, what's the first thing that you do? I don't know about you, but the first thing I do is check out their profile. I want to know who this person is and why she or he has chosen to follow me.

If I deem that this person is sufficiently interesting, not the person who bullied me in primary school, and reliably non-spammy, I might even grace them with a follow-back. Without a recognizably human profile image and something that resembles a description of a person, I wouldn't give it a second glance. Making yourself identifiable through your profile is crucial. You might be unique, but the chances are that your name isn't. If someone is searching for you on a social network, how can she or he identify you as you—and not as your puppy-torturing, blood-bathing, Satan-worshipping namesake—if your profile consists of nothing more than your first name and a photo of your cat?

Your profile is a tricky thing to get right: you want just enough information to be

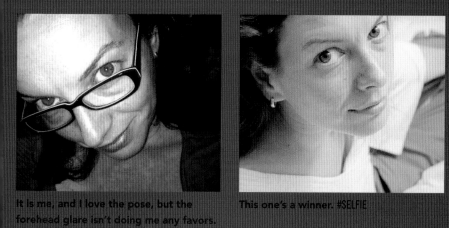

It is me, and I love the pose, but the forehead glare isn't doing me any favors.

This one's a winner. #SELFIE

informative, but not so much that you make yourself vulnerable; enough humor to raise a smile but not so much that people think you're a joke; and enough consistency so that people can recognize you between real life and across networks, but not so little that people think you're one-dimensional.

And you want a stonking good photo of yourself, too. They'll see your image before they read your bio and it's that image that they'll use to identify you every time they interact with you over the internet. You don't want to look like a corpse bride or an axe murderer. You want to look like you, and you want to look good.

My current favorite internet profile is, without a doubt, Hillary Clinton's Twitter profile: "Wife, mom, lawyer, women & kids advocate, FLOAR, FLOTUS, US Senator, SecState, author, dog owner, hair icon, pantsuit aficionado, glass ceiling cracker, TBD..." And it uses an instantly recognizable photo of her. It's informative, amusing, and intriguing. She tells you who she is, what she's about, and leaves you wanting to know more.

SOCIAL NETWORK PROFILE
checklist

☐ **Real name**—the handles-only approach was great back in the hack-tastic days of the late 90s, but now we've grown up and so has the internet.

☐ **Rough location**—not your street address, but the city where you live or town closest to you is a good start.

☐ **Interests**—to make it easy for like-minded people to find you amongst the millions.

☐ **Link to more**—whether you direct people from your Twitter profile to your Facebook page or include your blog from your Google+ profile, let people join the dots and find out more about you.

☐ **A photo of you**—not of your dog, of your baby, or of your favorite film star; own your account.

10 THINGS

YOU DIDN'T KNOW

ABOUT *social* NETWORKS

1
FACEBOOK'S THEME *color is blue* BECAUSE IT'S FOUNDER, MARK ZUCKERBERG IS RED-GREEN *colorblind.*

2

THE TWITTER BIRD IS CALLED *larry,* AFTER BOSTON CELTIC'S LARRY BIRD.

6

TWITTER STARTED OFF AS A GROUP SMS DEVELOPED AT A *one-day hackathon* BY JACK DORSEY.

7
THE MAJORITY OF MOBILE INTERNET ACCESS IS FOR *social networking purposes.*

3

THERE ARE *more photos* ON FACEBOOK THAN ARE HELD IN THE LIBRARY OF CONGRESS.

4

YOU CAN FOLLOW A *maximum* OF 7,500 PEOPLE ON *Instagram.*

5

IT WAS SEAN PARKER WHO CONVINCED AN *initially reluctant* MARK ZUCKERBERG TO INCLUDE A *photo-sharing* FEATURE ON FACEBOOK.

8

IT TOOK FLICKR TWO YEARS TO AMASS 100,000,000 IMAGES: INSTAGRAM ACCRUED THAT MANY IN *eight months!*

9

IT'S ESTIMATED THAT ONE IN FIVE *couples meet online;* BUT THE ROOTS OF ONE IN FIVE *divorces* LIE IN FACEBOOK.

10

OVER ONE THIRD OF INSTAGRAM ACCOUNTS *don't have any* PHOTOS IN THEM!

Acquiring FOLLOWERS

The whole point of social media is that it's, well, social. It's about building communities and being able to engage and interact with people with whom you have a connection. That connection can be anything from having the same parents to an interest in Neolithic wall art, but there's a tie that binds somewhere.

Much the same as any other type of relationship, you'll get out of your social media experience what you put into it. It's about reciprocation. If you want followers, you need to follow people. If you want retweets, you need to retweet other people's tweets. If you want likes, you need to like other people's posts. And if you want comments and feedback, you have to go out there and provide comments and feedback yourself.

There's no real secret to expanding your social media following: it's about being human. Be interesting and seek out other interesting people. Follow the people who amuse, entertain, inspire, and provoke you. Through them, you'll find other people who do the same, and by slowly building these connections, you're likely to expand your own network.

The concept of "being human" extends to your posting frequency, too. Imagine that you're at a party. You spot someone sitting in the corner, alone and looking glum. He might be shy or nervous, or not really know anyone, so you head over to him to say hello and exchange a few words. Except that you don't really exchange any words because you're the one doing all the talking. His answers are either monosyllabic or he just shrugs his shoulders. You try your best, but after ten minutes of virtual soliloquy, you decide to cut your losses and go find someone who actually seems engaged and engaging. It's the same with social media: if you don't post anything, people will stop making the effort to listen.

Meanwhile, back at the party you've just grabbed another slice of cake when you find yourself cornered by the wildly gesticulating woman with a foghorn of a voice who NEVER. SHUTS. UP. You can't get a word in edgeways. You find yourself desperately looking around for something, anything, that you can use to lever yourself out of this bombardment of words that have long since ceased to resemble anything like coherency.

Again, it's exactly the same with social media. When I encounter an incontinent poster, my finger heads for the "unfollow" button faster than they can say "Jiminy Cricket." They might have the odd gem amongst the onslaught, but it's lost in the debris, and worse, it swamps what other people have to say. So don't post too often, either. People will grow bored and impatient.

If you want to make an impact, don't be afraid to experiment. #SURREAL

THE
KEY
TO
aquiring
SOCIAL MEDIA
FOLLOWERS
DOESN'T RELY ON
ALCHEMY
OR
BRIBERY

IT'S ABOUT
BEING
INTERESTED,
interesting,
AND
INTERACTIVE

GOING *viral*

In a way, it's quite hard to give tips on how to make something go viral, because the entire point of it is that it captures a moment, which makes people want to share it. Aside from zeitgeist issues, most viral successes take an extant idea and make it better. They're normally funny, but they don't have to be. A friend of mine had a video go viral a few years ago. It was called "Glide 2" and was a slow-motion video filmed from a high-speed train. It wasn't funny, it was beautiful. If you can do something original, if you can surprise people and give them a new way to see the world, you're in with a chance of going viral. Unless you have friends in high places though, going viral isn't something you can force.

CITIZEN JOURNALISM

In the 1990s, the closest that anyone who wasn't a member of "The Press" came to being a journalist was to see their sharply worded letter published in the Letters to the Editor column of a newspaper. "The Press" was a tightly controlled body of news publications and TV and radio broadcasters. Reporters sought out the news and condensed it into easily digestible, contextualized formats for the public that would be given the "yea" or the "nay" by an editor. Certain authoritarian regimes still control what can and cannot be printed or broadcast as part of their attempts to retain power.

The internet has changed that model, though. Anyone can be a columnist on their blog, a photojournalist through user-submitted content to major news outlets, or an on-the-spot reporter via Twitter. The Arab Spring, for example, was co-ordinated by, and gained overwhelming momentum through the use of social media, but there was one event above all that cemented the strength of the social photographer as citizen journalist: Superstorm Sandy.

AS A PHOTOGRAPHER IT'S GOOD TO KNOW YOUR RIGHTS ▼ BUT AS A CITIZEN JOURNALIST THIS IS *especially* TRUE

As the east coast of the United States was battered by a storm of epic proportions in November 2012, ordinary people living through it were able to communicate events in real time. The world could see the devastation of a community through its own eyes, not those of an outsider. And it was mostly down to Instagram and Twitter. Roughly 1.3 million Sandy-tagged images were uploaded to Instagram during the storm and in its immediate aftermath. Suddenly social photography wasn't just about your coffee, your cat, or your kids any more.

Citizen journalism is first of all about being in the right place at the right time. But then you need to ensure that it's your images or video—which aren't just a blurry haze—that break that news.

A geotagged, hashtagged, and well-captioned upload to Twitter is probably your best bet: it helps to be able to verify it, for people to be able to identify it, and for you to give it a helping hand by encouraging people to look in the right place. A well-directed @-message or two will help it on its way!

Protect yourself and your equipment by finding out what you are and are not allowed to do as a photographer—before you get into a situation. You don't have to be a legal expert; a quick Google search on "photographers' rights" will give you plenty of information.

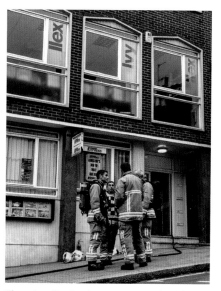

There's a fire in the newsroom, but the first person to cover the story is the guy with an iPhone and a Twitter account! #CITIZENJOURNALISM (© Frank Gallaugher)

Cautionary TALES

Everyone must have heard a social network horror story at one time or another; from parties gate-crashed by hordes of strangers, to accounts being closed for no apparent reason. Whether it's about common sense or playing by the rules, they all serve as cautionary tales of what to do (or not do) when it comes to interacting across social media.

NUDITY:

Lots of social networks, including Facebook, Google+, and Instagram, take a rather dim view of nudity and if you're not careful you can find yourself in hot water for posting images that they consider too revealing. It doesn't matter if the photos are just on the acceptable side of pornography or as innocent as a newborn baby being breast-fed: boobs and bottoms aren't allowed.

Daniel Arnold found this out the hard way when his Instagram account was shut down after he shared some photos of women bathing in the nude on a New York beach. The photos weren't particularly shocking, but nudity is banned according to Instagram's Terms of Service and Arnold breached them.

Whenever you go to share a photo, ask yourself if your mother would be ashamed of it or if your boss could haul you over the coals for it. It's not a perfect barometer, but it's a useful safety check.

Flickr is a little more forgiving and provides users with the option to self-moderate their content. If you want to post an image that's a bit on the risqué side, you can mark it as "moderate" or "restricted" to provide a warning to people before they see an image that it might be a bit naughty.

LIBEL:

Libel and defamation laws vary the world over, but the general rule is that you shouldn't write something about (or print images of) someone that can damage her or his reputation, or put them at risk of contempt or hatred from other

people, if you can't be sure that it's true or that other people will regard it as an honestly held opinion. It doesn't matter if what you publish is in traditional media or on a social network, if it's out there for other people to see, you're at risk of being sued. If you're convicted of libel you won't get a criminal record (at least, not in the UK), but you might land a hefty damages bill.

LICENSES:

We've already touched on the licenses issue, when we looked at Instagram. I can't tell you how important it is to read the Terms of Service, Terms and Conditions, or Terms of Use carefully when you sign up to a social network. You don't want to see one of your holiday photos being used by an international conglomerate with an advertising budget of millions on billboards the world over, but without you receiving a penny or even a name check for your efforts. It's bad for you and bad for photography as a medium.

Your aim is to keep as much control over your images as you can, and always keep your copyright. A lot of the time, you have to wade through verses of legalese and it's enough to make you feel queasy, but some sites give a "translation," which is both helpful and confidence-boosting. Good things to look out for include affirmations that the network requires a license for your images only for the functioning of the site or for the provision of the services that you signed up for, or that they won't sell on your images. You will be granting a world-wide royalty-free, non-exclusive license to modify, reproduce, and adapt the content but if you didn't, the site wouldn't be able to share your images with your friends!

KEEPING SAFE:

When you're out and about taking photos you always have to be aware of your environment. Whether it's because your kit makes you vulnerable to mugging or what you want to shoot is precariously positioned, getting a photo is never worth endangering yourself.

Sharing your images via social media makes you even more exposed. From your posts it can be very easy for people to determine where you are, if you're alone, if your house is empty, and many other snippets of information that can put you at risk.

WHAT GOES AROUND COMES AROUND:

Being a faceless entity, it's easy to forget that whatever you share on the internet has the potential to be seen by anyone, anywhere, across the globe. Anthony Wiener discovered this to the cost of his post as New York Congressman after he mis-shared a rather revealing photo of himself on Twitter.

Even with stringent privacy settings engaged, things still have the potential to go awry. Mark Zuckerberg's sister got into a rather significant pickle when a photo of her family that she'd placed on Facebook was tagged by a friend and subsequently widely shared when she thought she'd locked it down. And you really wouldn't want to post photos of yourself rocking out at a music festival after having told your boss that you were close to death with a vicious strain of incredibly rare gastroenteritis, forgetting that she's a friend of yours on Facebook, or that she's a Twitter follower of one of your friends who retweeted one of your photos.

THE NEXT *big* THING

All empires fall. One day, Facebook will be but a shadow of the internet behemoth that it is now; Twitter will be a distant memory; and Flickr will be consigned to the annals of history. Instead, we will be sharing our thoughts, experiences, and images via means that aren't yet even glimmers in the eyes of their founders, which haven't even entered our wildest, most science-fictional of dreams.

When you're living in an era when one retailer, one sports team, one superpower, or one social network is dominant, it's hard to imagine life without it. Change can come through slow decline or sudden usurpation, but it will come. You can stay a step ahead by recognizing that change and adapting. You've heard about a hot new thing? Try it out! Your best friend invites you to join a cool site? Sign up! You don't have to give up on the places where you already spend your time, and you don't have to hang around these new-fangled experiments if they don't agree with you, but when you find something you love and think everyone else will, you can be a part of the change as it happens.

I never knew whether this was real or not. Either way, a spooky reminder that nothing lasts forever. #SPOOKY

The secret behind any social network, whatever its focus, will always be to remember that real people exist behind those pixels on the screen.

Everything moves quicker on the internet. Information can be shared around the world in an instant, and trends can form seemingly overnight. Everyone wants to be or to create the next big thing, but what distinguishes the fad from the phenomenon that's here to stay?

Below are six examples of six sites or applications that have all enjoyed popularity. At the time of writing, some of them are going strong, some have evolved in order to survive, and some are already extinct. Tomorrow, of course everything could be different…

1. SNAPCHAT

Launched in 2011. An ephemeral photo-sharing service. Snap a picture and send it to someone, but much like Mission Impossible, it self-destructs after it has been viewed. Where is it now?

2. FLAYVR

Launched in 2012. A photo curation app that compiles your photos and videos into albums based on when and where they were taken, leaving them ready to share with your friends and family via Facebook, Twitter, Google+, email, or message. Where is it now?

3. PATH

Launched in 2010. Share photos, music, and videos privately, with the people who matter the most to you. Everything's kept close: Path doesn't allow more than 150 connections. Where is it now?

4. PICPLZ

Launched in 2009. An Instagram-esque photo-sharing app that had the initial edge over its rival because it was available on iOS and Android from the start. But where is it now?

5. COLOR

Launched in 2011. Color raised $41 million in funding straight off the bat, based on the reputation of its two co-founders. It started out with the aim of bringing together people who were in proximity to each other, for example at a gig, through their photos. That didn't quite work, so it pivoted to sharing videos, but where is it now?

6. MYSPACE

Launched in 2003. Myspace was the place to hang out when it launched. So much so that News Corporation bought it for $580 million in July 2005. In June 2006, it had more visitors in the US than Google, but then along came Facebook. Where is it now?

1. At the time of writing, Snapchat is enjoying a moment in the sun as users enjoy sending each other silly faces (as well as some other things they probably shouldn't).

2. Flayvr looks to be on the rise as it receives user approval for its quality and efficiency.

3. After three years on the circuit, Path is at last beginning to look like it might be a serious contender to Facebook's crown… Watch this space.

4. Extinct. Instagram began pulling ahead in 2011, so its rival, PicPlz, finally called it a day in July 2012.

5. Also extinct. Despite the pre-launch buzz, Color never really took off. After several attempts to reinvent itself, Color closed its gates in October 2012.

6. The end was looking near for Myspace as users abandoned it for Facebook, but incredibly the network managed to recover, recreating itself as a hub for music and creativity.

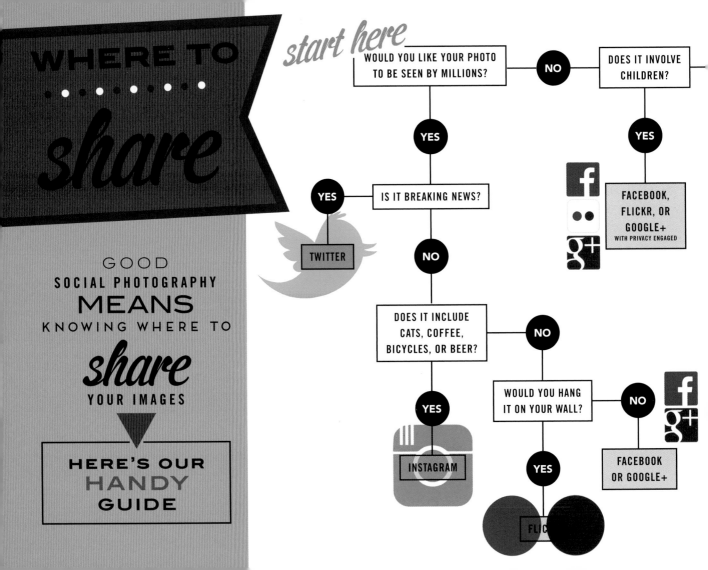

WHERE TO share

GOOD SOCIAL PHOTOGRAPHY MEANS KNOWING WHERE TO *share* YOUR IMAGES

HERE'S OUR HANDY GUIDE

start here

WOULD YOU LIKE YOUR PHOTO TO BE SEEN BY MILLIONS?

NO — DOES IT INVOLVE CHILDREN?

YES

IS IT BREAKING NEWS?

YES — TWITTER

NO

DOES IT INCLUDE CATS, COFFEE, BICYCLES, OR BEER?

YES — INSTAGRAM

NO

WOULD YOU HANG IT ON YOUR WALL?

YES — FLICKR

NO — FACEBOOK OR GOOGLE+

YES — FACEBOOK, FLICKR, OR GOOGLE+ WITH PRIVACY ENGAGED

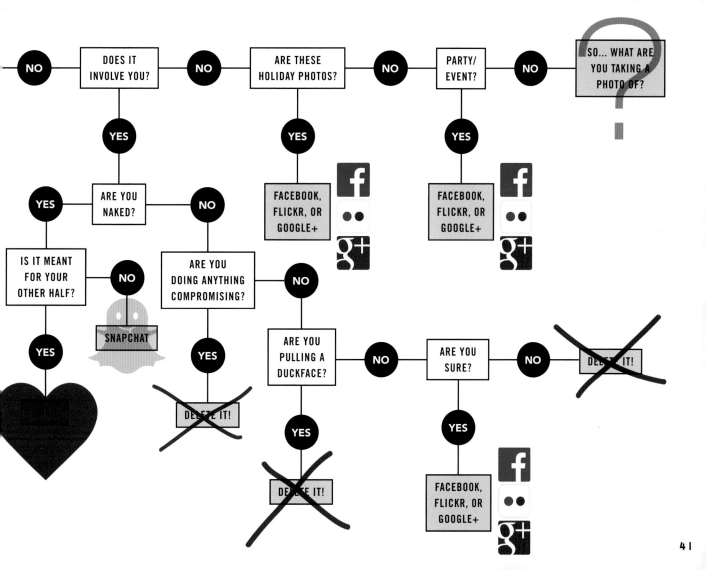

41

Chapter 2

Compose

YOURSELF

It doesn't matter if you're using your smartphone's native camera app or prefer to use the camera feature included in a specific app; you need to know your way around the camera and what works—and what doesn't—in a photo!

THE IPHONE *camera*

When it comes to smartphones, Apple's iPhone is iconic. Before its arrival most of us used point-and-shoot cameras to take our holiday snaps. Steadily, the iPhone camera and its interface with the photo-sharing world has improved to the extent that it has helped make the compact camera all but obsolete. Shall we take a closer look at what all the fuss is about?

Whatever the current version of the iPhone, the next one will have an improved or augmented camera app. It's the way of the world. But there are some features you should definitely know about, if you're not already making use of them.

BACK-FACING
(HIGHER RESOLUTION)
CAMERA WITH A
WIDE-ANGLE LENS

FLASH

FRONT-FACING (USUALLY LOWER RESOLUTION) CAMERA

CAMERA QUICK ACCESS FUNCTION
You know that there's a quick camera access function, yes? You don't have to unlock your phone; just go to the lock screen and swipe upwards from the camera icon in the lower right corner. You won't be able to edit a photo without accessing the phone itself, but who's worried about that when you're hurriedly trying to capture your niece taking her first steps?

Sitting beneath the "Options" button are the grid feature, the HDR function, and the panorama mode on newer phones. You'll learn more about those later. And very useful they can be, too.

The flash was probably set to auto when you first bought the camera. Switch it off. Much better!

If you want to switch between the front-facing and back-facing cameras, tap here.

Take a photo!
(YES, EITHER OF THESE WORK!)

By tapping on the screen you can tell the camera where it ought to be focusing, not where it thinks it wants to be focusing (see Tip, right).

I don't recommend using the zoom feature (more on why not a bit later), but if you do need to use it, make a pinching action on the screen and a slider will appear at the bottom.

All your photos are stored on the camera roll. You can reach it from here.

And to switch between camera and video, slide the button from the camera icon to the video icon in the bottom right of the camera screen!

AE/AF *lock*

If you hold down your finger on the screen where you want to focus, you can lock the focus and the exposure. You'll see "AE/AF Lock" appear at the bottom of the screen if you've activated it successfully. This will allow you to move your phone around to recompose your shot, while keeping the focus and the exposure fixed.

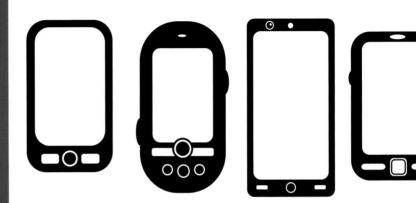

The iPhone might be the most iconic smartphone, but it most certainly isn't the only one out there. It hasn't been responsible for the decline of the compact camera on its own: HTC, LG, Nexus, Nokia, Samsung, and Sony have had their parts to play.

These smartphones operate on different platforms to Apple products. Anything Apple runs on iOS, but the majority of other smartphones run on the Android operating system. Don't be overwhelmed by the almost cult-like devotion that some people have for either Apple or Android. Fanboys can be a bit fanatical. Ignore their ravings and use whichever smartphone meets your needs. It isn't as if you'll be cast adrift in a sea of photographic confusion because the camera app is slightly different.

The praise for the cameras in Nokia phones, especially the Pureview and Lumia models, has been exceptional. However, they come with a significant drawback: they operate on a Windows platform and many of the apps that we take for granted with Apple and Android phones just aren't available. In fact, you often hear Android users complain that it takes longer for them to have access to apps that Apple users have. In comparison to Apple, there's a bit

Photographers OFTEN SAY THAT **THE BEST** *camera* IS THE ONE THAT YOU HAVE WITH YOU

smartphoneography HASN'T NEGATED THAT SENTIMENT **IT HAS** *reinforced it*

of a shortage of Android developers out there, so things do sometimes take that bit longer to go cross-platform.

There are some particular advantages to using a smartphone that isn't Apple, though. The designers and developers have taken note that photos and social sharing are high up on the priority list of people who use smartphones and they're producing cameras to match this need. These cameras are growing evermore capable, especially when some manufacturers, such as Samsung and Sony, have feet in both the phone and the camera markets.

WHAT DO WE MEAN BY *app?*

"App" is short for application. It's a specialized program, dedicated to one function, that you can run on an electronic device. Your smartphone will have a camera app, from where you operate the camera feature, and you'll access Flickr, Twitter, and Instagram from their respective apps. But you can't reach Google+ from the Facebook app.

You can download apps for Android devices from Google Play, and Apple apps from the App Store. Blackberry, Microsoft, and Nokia all have their own stores too. Many apps are free, though some you have to pay for. To download an app go to your store, find the app, and hit install. Once it's installed you can access the app from your apps menu or homescreen.

EMBRACING THE **WIDE** ANGLE

If you're interested in photography, chances are you'll have heard the terms "wide-angle," "telephoto," "zoom," and "focal length" being bandied about. How they affect your images is important, but thankfully they're not difficult concepts to grasp. Focal length is the distance from the optical center of the lens to the sensor. It's measured in millimeters and the greater the number of millimeters, the longer the lens, and the closer your subject will appear to be.

A shorter focal length means a wider angle of view with a subject that takes up, comparatively, less of the frame. Lenses with shorter focal lengths are known as wide-angle lenses; long focal lengths are telephoto lenses; and focal lengths somewhere in the middle are called "standard" lenses.

Most compact cameras come with zoom lenses that can switch between wide-angle and telephoto views, something

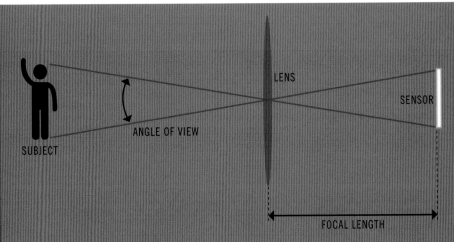

SUBJECT

ANGLE OF VIEW

LENS

SENSOR

FOCAL LENGTH

LONGER FOCAL LENGTH = NARROWER ANGLE OF VIEW

that depends on complicated moving parts. Interchangeable lens cameras have, rather obviously, lenses that can be changed depending on whether you want a wide-angle, standard, or telephoto view. Sometimes these are zoom lenses and sometimes "prime" lenses that have a fixed focal length.

Having a lens that zooms on a smartphone isn't terribly practical, and, while we can digitally zoom toward a subject, we can't digitally zoom away from one, which means that smartphone cameras tend to have lenses toward the wide-angle end of the spectrum.

Wide-angle lenses are awesome for some types of photography, but not so great for others. Have you noticed how you can easily squeeze most of a room into a photo taken with a smartphone camera, or you can photograph yourself amongst a group of your friends, holding the camera at arm's length? And how close-up portraits can give people chins and noses that are comically large and out of proportion? That's because smartphone cameras have wide-angle lenses.

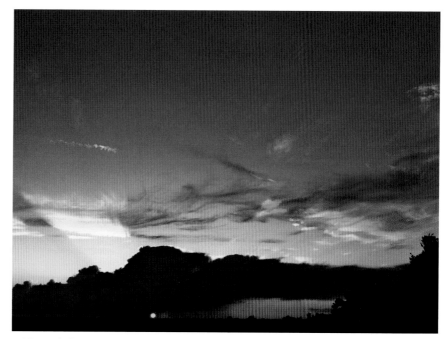

Wide-angle lenses are wonderful for sweeping views, such as this sunset across Long Hill, in Newmarket, UK. #SUNSET

The answer to dealing with the limitations of a wide-angle lens is to embrace it, and turn it to your advantage. Normally, we'd say get in close to your subject with your camera and fill your frame with it. This doesn't work so well with wide-angle lenses and portraits. Instead, step back a little so that the angle is "normalized," and then crop your image to "get closer." Alternatively, photograph someone from above: you'll give her or him a big head and tiny feet.

LOVING THE *flaws*

The secret to making the most out of your smartphone camera is to know its flaws and to work with them. Here we will take a look at the top five smartphone camera foibles.

1: FLAMING LENS FLARE

Lens flare shows up in your photos as streaks of light you see close to bright objects. It happens when stray rays of light are reflected, and refracted, and distorted by your lens.

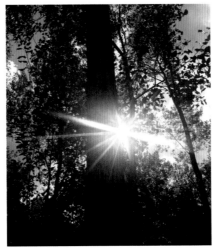

This is what happens when you shoot into the sun! #LENSFLARE

The easiest way to avoid lens flare is to not shoot into the sun or any other bright light. If you can't avoid this, try cupping your hand around the lens to act as a shade. It helps to prevent stray light hitting the lens, otherwise, it will just be a case of using it creatively!

2: WOBBLY WHITE BALANCE

Light has a "temperature," and depending on the source of the light, or the time of day if it's the sun, that temperature will vary. When the temperature varies, so does the color of the light.

As a general rule, we don't notice the variation because our eyes cleverly adjust to the changes. Our cameras on the other hand aren't quite so clever. Have you ever noticed how white objects in your photos can show up with blue or yellow casts? That's because the white balance in your photo was off.

The easiest way to correct white balance is in post-processing. Apps such as Snapseed or Photoshop Express have a white balance adjustment feature that you can use to correct white from an odd hue to actual white.

Physically closer or...

...Digitally closer? See?
#DIGITALZOOMSUCKS

3: DIGITAL ZOOM SUCKS

There's no kind way of putting this: digital zoom sucks. One day it might not, but right now, it does. It sucks because it isn't really zoom: instead it crops out the section of the image to which you want to get closer, enlarges it, and discards the extraneous pixels. All that lost data! It means that the quality of your images won't be as good as it should be.

If you want to get closer to your subject (and you almost certainly do; more on that on page 56) the best way to do it is physically. Move your hands closer and your feet closer.

4: THEY CAN'T SEE IN THE DARK

Compared to DSLRs, smartphones are at a serious disadvantage when it comes to shooting in the dark. Their sensors aren't as capable of picking up what light there is; you can't control the shutter speed; the flash is far too harsh; and the resulting images can be so noisy they give you a headache. That's if the autofocus even knows where to find your subject in the first place.

All of this makes it sound as if smartphone shooting in the dark is worse than a trip on the scariest rollercoaster with a tummy full of chips, ice cream, and fizzy pop. It isn't, though. We've some helpful hints and handy tips for shooting in the dark, but you'll have to wait until page 102 for them.

5: A GENERAL LACK OF CONTROL

If you're accustomed to using a camera where you have full control over your aperture, shutter speed, and ISO, the fixed aperture and inability to determine your exposure can feel as if you've been put in a creative straitjacket. You haven't, though. You just have to go back to the basics: choose your story and compose your scene properly.

Embrace the limitations
AND USE THEM TO FORCE YOU TO GET THE FUNDAMENTALS RIGHT.

CAPITALIZING ON THE *capabilities*

Sometimes small is best. #LIVE #DISCREET (© Haje Jan Kamps)

After reading about the smartphone's flaws you might think it's all doom, gloom, and miserable compromise. No way! You've got an awesome camera that fits in your pocket and can share the photos of your new apartment with your friends faster than you can sign your name on the lease. It also has some rather nifty properties of its own that some DSLRs and traditional point-and-shoot cameras just don't have.

who

WANTS TO TAKE

A DSLR

TO A

concert?

We'll look at your editing options to improve the look of a photograph in the next chapter. For now though, let's think about what the camera can do for itself.

First of all, it's phenomenally discreet. You can pull out your phone to photograph something in the street and no one will give you a second glance. Try doing that with a DSLR!

Second, smartphones have an easily accessible and frequently image-saving HDR function. If you think that HDR means garish colors and plastic skies, think again. When used to good effect, it can pick up a much larger range of tones in your photos than a camera normally can, which is fabulous for photographing scenes with some areas that are very bright and others that are in shade.

If you wanted to do this with a DSLR, it would involve taking at least three photos at different exposures and then merging them together in post-processing. What a palaver! Your camera phone? It can do it with a few taps.

Whenever you're faced with a scene that leaves you wondering how on earth you're going to see the details in the shadows without having a huge expanse of blindingly overexposed sky, fire up the HDR option. You won't be disappointed.

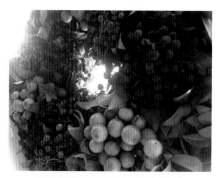

Shooting in very bright light meant that capturing the detail and color depth of this wreath was difficult. By using the HDR function, I was able to retain the detail without over- or underexposing the photo. #HDR

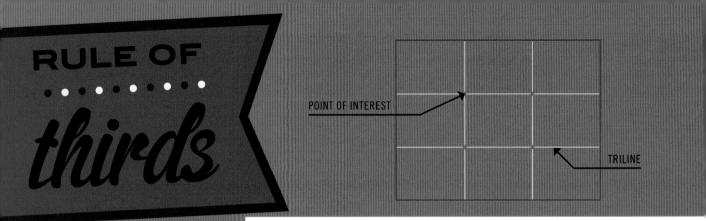

RULE OF *thirds*

THIS GRID IS YOUR *guide* FOR COMPOSING *an image*

We have a natural tendency to place our subjects in the center of the frame. It makes sense, logically, to have our point of focus right in the middle, glorified by its surroundings and unavoidable to the eye. Except that centered subjects don't often make for very interesting images and they won't hold the eye's attention for long. There's an unmistakable flat and dull quality to them.

Next time you're watching a film or TV, notice where the heads and the eyes of the people doing the talking are. I'll bet they're not in the center of the frame. Instead, they'll be positioned slightly to one side. They'll be making use of what's called the rule of thirds.

Imagine that your frame is divided by four lines: two running horizontally and two vertically. They are equally spaced and split the frame into nine smaller rectangles. The points at which the four lines intersect create four "points of interest."

Take a look at the settings on your camera; there's probably a grid overlay to help you so you won't even need to just imagine it.

Aim to position subjects that run upright in your image along one of the vertical trilines. Lines and subjects running across the image—especially skylines and horizons—should run along a horizontal

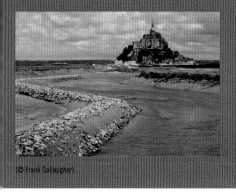
(© Frank Gallaugher)

triline. (Definitely not through the center with a horizon unless you've got a good reason for it.) For maximum visual impact, anything that's of particular significance to the composition—for example the eyes in a portrait or the sun in a sunset scene—should be placed on one of the points of interest.

If you've never tried it out before, give it a go: you'll be amazed by the difference it makes. It brings a dynamic balance to your image that a centered subject can't manage. And once you start thinking in this way about composition, I guarantee you'll never look at a scene you want to photograph in the same way again.

The frustration of one missing piece from a 1,000-piece jigsaw meshed with the rule of thirds. #RULEOFTHIRDS

5

COMPOSITIONAL

RULES

FOR *great* PHOTOS

GET CLOSER:

Don't leave your audience squinting at a photo, asking you quizzically "What am I supposed to be looking at?" Get closer! Fill the frame! Make the subject big, and bold, and obvious!

FRAME ORIENTATION:

Tall things need portrait orientation; wide subjects deserve landscape format. People, trees, and skyscrapers go up; landscapes and palaces go across. Use the orientation of the frame to enhance the subject.

No distractions from my drink here!
#CIDER #GETCLOSER

Even headless bodies go upwards!
#ORIENTATION (© Haje Jan Kamps)

LEADING LINES:

You don't want a flashing neon sign drawing the eye to the subject, but look for a line that leads the eye across the image and to the focal point. The best photographs keep the eye interested, and a line to follow always helps.

STRAIGHT HORIZONS & UPRIGHTS:

The inner ear knows that the horizon should be level, so when it sees one that is slightly out-of-kilter it automatically feels disoriented and uncomfortable. This makes for a poor viewing experience and a weak photo. Keep that horizon level! Similarly, unless you happen to be in Pisa, make sure your buildings aren't leaning.

NEGATIVE SPACE:

Sometimes your subject needs room to breathe. It doesn't need a cluttered and busy background, and it needs a bit of space. This absence of anything in the frame is called "negative space" and it can do wonders for concentrating people's attentions on the subject.

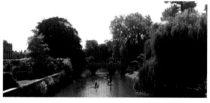

The horizon is skewed by only a few degrees, but that's enough to confuse your inner ear. #WONKY

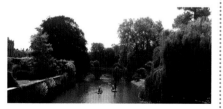

Much better! #STRAIGHTHORIZON

My legs lead you up to the tips of my toes. And then back down again! #LEADINGLINES #IMPLIEDNUDITY

The black nothingness forms a beautiful contrast to the portrait here. #NEGATIVESPACE (© Haje Jan Kamps)

5 more

COMPOSITIONAL

RULES

TRIANGLES:

Geometrically, the triangle is a strong shape. It's also aesthetically pleasing. When you have groups of items in your scenes, try to arrange them triangularly. Scalene, equilateral, or isosceles, it doesn't matter. Opt for a triangular arrangement and your image will be three times stronger—guaranteed!

Three's a party! #TRIANGLE

COLOR:

Pair blue with orange, yellow with purple, or red with green and you're on course for a contrastingly gorgeous image. Alternatively, pick one color and fill the frame with so many tones, shades, and variations on it that people will run out of words to describe them. Watch out for ugly clashes, and keep your eye open for color combinations you find interesting or attractive.

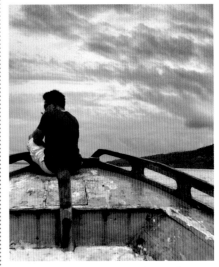

Orange boat against blue sky: perfect!
#COLORCONTRAST (© Haje Jan Kamps)

PATTERN & REPETITION:

The human eye loves patterns, repetition, and routine. Trust me, this isn't about being boring; it's about creating an image that the eye thinks is pleasing. Cropping in close can help by stripping out the context, and can easily make the shot more abstract.

FRAMES:

Just as it likes pattern and repetition, the eye likes boundaries, too. It prefers to know where things begin and end. Placing frames-within-the-frame is an excellent means of creating a strong image. Look for windows, archways, and trees and branches: anything that creates an edge and draws attention to the subject.

ANGLES:

Don't think that you always have to shoot straight on to your subject. Get down on your knees and up on a ladder. Try shooting the same subject from lots of different angles and see what it does to the image. Experiment! One effect you can be sure of is that you'll find yourself taking much more interesting photographs, and even mundane subjects can be come striking.

Shop windows are often a great source for patterns. #REPETITION (© Frank Gallaugher)

Framing your shot carefully will give a real edge to your composition. #FRAMES

Drink up! #GETDOWN (© Haje Jan Kamps)

IT'S HIP TO BE *square*

Nothing's quite centered, but the square format invites your eye to wander around the frame while the darker edges draw focus back into the center. #SQUARE

Dynamic tension in a square frame

Part of what makes Instagram images so distinctive, apart from their filters, is their square crop. Medium format cameras and Polaroid film meant that square crops used to be quite common, but the ubiquity of cheap 35mm cameras changed that and they fell out of fashion. They're right back in and swinging with their retro feel now, though!

If you're used to shooting with a rectangular frame, one thing will strike you immediately about the square crop: the traditional rules of composition aren't as effective here. The square format demands that you think differently.

For one thing, the tension in a square frame is entirely different to a rectangular frame and dynamic subjects don't seem so comfortable within their bounds. Rather than move across the frame as it would with a rectangular crop, the eye tends to move around a square one.

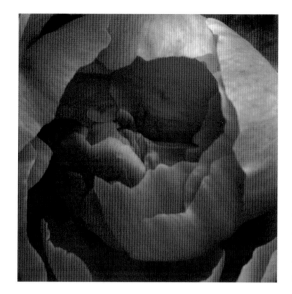

There's something about the square crop that adds a touch of elegance to a floral close-up. #SQUARE

A square can be hard to compose because it's a strong, geometric shape. So look for subjects that themselves make a strong shape: circles in squares; radial, diagonal, or intersecting lines; subjects that are symmetrical or patterned—and compose to make sure they sit perfectly centrally.

With symmetry, radial lines, and a vignette... It had to be square!

Square crops are often best suited to the serene. Think posed portraits, still lifes (and especially flowers), some architecture and landscapes. Aim for single subjects with understated backgrounds to work best in your square frame.

When it comes to composing a square shot, it can help to think in triangles. Split the frame in two along a diagonal and introduce balance into the image through that line.

Centered subjects can kill an image in a rectangular frame, as we saw earlier in the chapter. In a square frame, however, a centered subject works an absolute treat. Because the square has no vertical or horizontal bias, there's a balance that comes with the shape and positioning. Even better than a centered subject? A symmetrical subject. There's a perfection that only a symmetrical subject placed within a square can enjoy.

BREAKING THE rules

Rules are there for a reason. Mostly, they make life easier: they give us a framework and let us know what to expect. Can you imagine what the roads would be like if there weren't any rules? No one would know when to stop, when to go, where to walk, ride, or drive, or what to do. In short, it would be chaos.

Photography's rules aren't quite so critical for everyone's well-being as the rules of the road, but they do make life easier. The rule of thirds guides your subject placement, leading lines direct the viewer's eye, and color theory helps you to compose your frame. All of these factors, and more, work together so that you can create a strong image.

There are, however, times when the rules can (and maybe even should) be broken. The key to breaking the rules is to know them first, so that when you do break them it's with a purpose; and the purpose is to create an even better image.

We've already seen why horizons must be straight, but you can set them at an angle if you want. In this case it's vital to make the angle so obvious that there's no possibility of confusion for the inner ear. And then it's called a Dutch Tilt.

Simple compositions tend to be the most effective because they draw the audience into the story straight away. But when you need to convey a sense of busyness and bustle, you need a frame rammed with action and activity.

The eye loves patterns, but when a pattern breaks it can deliver the focal point for your image. Look for the red apple in the pile of green, or that one left-facing head in the sea of people looking right.

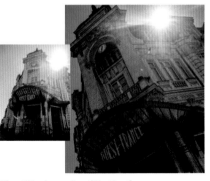

The tilted version fills the frame more effectively, avoiding any large areas of empty sky. #DUTCHTILT (© Frank Gallaugher)

There's a white interloper amongst the red potatoes! #BROKENPATTERN

There's so much to look at in this image—satellite dishes, washing lines, minarets, roofs—that you hardly know where to start, but that's exactly the point. I've added a slight vignette to draw the focus toward the center of the image. #TRAVEL #VIGNETTE

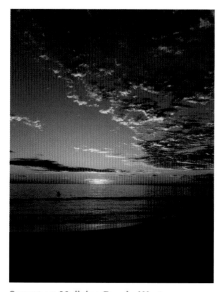

Sunset on Mullaloo Beach, Western Australia. #VERTICALLANDSCAPE #SUNSET

A "portrait-oriented landscape" defies convention right down to the name, but I love them! There's something about the great expanse of sky rising into the ether that is so evocative.

With each rule, think about what it is that makes it work, that makes it a rule. When you've done that, you can turn it on its head and create a stronger, more interesting and intriguing image!

vignettes

Vignettes lighten or darken the edges, most noticeably the corners, of an image. They were common aberrations on old lenses, but now we tend to add them in post-production to bring focus to the subject. They're a useful tool, but go easy: an over-done vignette is distracting rather than focusing.

say
·····●·○·○·○·○·○·●·····
CHEESE!

5
SIMPLE STEPS
TO
▼
super
S N A P S

WHAT'S YOUR STORY?

1 Think about what you want to convey in your photo, and shape the way you compose it around this idea.

CLEAN YOUR LENS

2 Give your lens a quick wipe. You never know where it's been.

CHECK THE LIGHT

 Where's the light coming from? Unless you really want that lens flare, don't shoot into the sun!

COMPOSITION?

 Is the composition the best it could be? Use the checklist below to make sure:

☐ Are you close enough? Are you sure?

☐ You've made sure that your frame is doing justice to your subject?

☐ Checked your subject placement?

☐ Your lines are straight and level? For certain?

☐ There's nothing creeping into the background that you don't want there, no?

☐ Are you using The Rules? If you're not, are you breaking them properly? Definite? If not, better use The Rules.

HOLD STEADY!

 We don't want any camera shake! Rest your camera phone on something if you can; lean against a tree, a post, or anything else sturdy, or with your elbows pushed into your tummy for stability if you can't. Take a deep breath.

click!

And don't move until you know that the shutter has closed again.

Chapter 3

Shooting FOR A Look

It's very rare that a photo can't benefit from a little editing love to make it sparkle. A swift crop here and a subtle boosting of color there can make all the difference.

THE
3
Cs

Whenever you take a photo and plan on sharing it, there are three edits that you should always look at making. They're not extensive—it's not about airbrushing away half of someone's thigh—and they're not complicated, so you won't have to spend hours getting frustrated with an editing app. These edits are very simple, but I guarantee they will make the world of difference to your photographs.

The essential things to look at are the Crop, the Color, and the Contrast of your photo: the three Cs.

CROP

However well composed you think your image is, it will almost certainly benefit from having a few pixels shaved off it. It might be a case of reinforcing the rule of thirds, removing a bit of unwanted background that crept into the frame, or getting a bit closer to your subject.

Being a purist, I tend to stick to traditional 4:3 or 3:2 ratios, but don't feel limited by my prejudices. Whether you use the camera's editing functions or a third-party program, you can select any of the standard crops, from square to 16:9, or free-style it to adjust the crop any way you like.

By slicing away some extraneous foliage in this photo, I'm able to draw more attention to the blueberries and bring more life to the photo without a centered subject. #TASTY #CROP

CONTRAST

Contrast is the difference between the dark and light tones in your photos. Images shot on bright sunny days tend to have a lot of contrast, with dark shadows and bright highlights, but those taken in fog won't have a great deal of tonal variation and will be low contrast. From time to time, you'll want a low-contrast image, but, generally speaking, your photos can be improved by increasing the contrast a touch. It brings definition and depth to them.

Don't go overboard, though, as too much of a good thing can turn bad. You'll find that if you over-cook the contrast you'll lose too much detail.

Sometimes pulling up the contrast brings out graphic qualities that you didn't even know were there. #CONTRAST

(© Frank Gallaugher)

COLOR

I mentioned earlier how camera phones often have a slightly skewed white balance, which can make the colors in your images appear weird. Now is the time to fix this. Snapseed is one of my favorite apps for adjusting the white balance in my photos, and I do it by eye. Normally I find that the whites are coming out too blue, so I have to nudge the slider to the right to introduce some redder tones and produce "white" whites.

Sometimes I also make the colors more intense by increasing the saturation. Not too much, though, or your shot will look more like a cartoon than a photo!

The original image of this pink peony was so badly white balanced that it looks almost purple. Shifting the white balance slider to the right has helped revert it to pink. #PRETTY #WHITEBALANCE

Black & white

I'm a huge fan of the black and white portrait. I love color, too, but there is a classical elegance to photographs of people in black and white, that together with its miraculous skin tone evening properties, leaves them unsurpassed.

Whichever app you use, there's a black-and-white filter that will transform your photo from color to monochrome in a flash. Twitter has just one black and white filter, but Google+ has several options sitting beneath its Black & White button, and Flickr and Instagram have a few. Flickr's basic filter is called "Newsprint." Instagram has "Inkwell" and "Willow." Inkwell is a basic black and white, but Willow adds more pinks to the mix. While it doesn't make it look pink, it helps to soften skin tones, which makes it perfect for portraits.

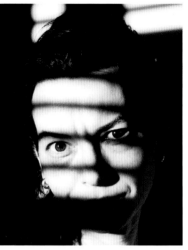

#GOOGLE+ #BLACKANDWHITE

A regular selfie shot with a DSLR. Apps are perfect when you want a quick-and-easy monochrome treatment.

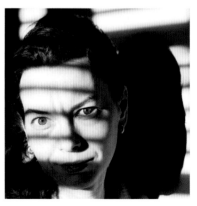

#INSTAGRAM #INKWELL

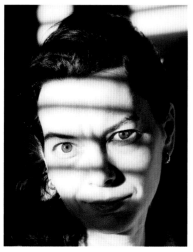

#FLICKR #NEWSPRINT

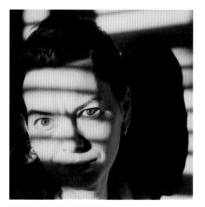

#INSTAGRAM #WILLOW

SNAPSEED

If you want to take a little more control over your black-and-white conversion, try Snapseed. It gives you six different black-and-white filters and lets you control the brightness, contrast, and grain in each. It also lets you control the dominant channel in the light mix. That might sound like gobbledy-gook, but when you remember that white light comprises the entire spectrum, it makes more sense. You're just determining whether red, orange, yellow, or green light is stronger. Or you can opt for a neutral blend.

As a general rule, portraits will look better with increased red wavelengths. It does marvels for skin tones.

Don't think that black-and-white is just for portraits, though! Be on the lookout for black and white opportunities in atmospheric landscapes, strong still lifes, and gritty street photographs.

Here, I used Snapseed's "Film" black-and-white setting. You can see how you get a nice grainy effect with this filter. #SELFIE #SNAPSEED #FILM

Retro

· · · · · ·

TONES

#GOOGLE+ #RETROLUX

#FLICKR #ANTIQUE

#TWITTER #1972

#FLICKR #THROWBACK

King's College Chapel, Cambridge, taken from the Backs one very warm morning. #TWITTER #ANTIQUE

Most of Instagram's filters can give you an aged look, but start with 1977. #1977

If you're looking for a retro-feel filter, you have a gamut from which to choose sitting at your fingertips. First, you should probably choose between a sepia or color effect. For a sepia look, I prefer Twitter's "Antique."

For color, you might want to start with the pink cast and distressed look of Google+'s "Retrolux 1" or the greener tones of "Retrolux 2." "Antique" and "Throwback" are Flickr's most obvious choices, while Twitter has "1963," which

This strawberry bed, snapped to show my friends how well the strawberry plant that was the favor from their wedding was growing, has been given the Amber + Local treatment in Pixlr-o-matic. #RETRO #PIXLROMATIC

Snapseed provides you with more control over how the filters are applied than other apps. #RETRO

looks soft and pink, or "1972," which is a little sharper and yellow in tone. Instagram has a huge selection: "1977" is probably the most obvious, but "Amaro" and "Valencia" have an aged feel to them too.

If you're not feeling these retro-tones, but still want to be able to fire up the time machine before you launch your photos at Facebook or Google+, you do have options. For an easy retro-fit package with a lot of style options, look no further than Pixlr-o-matic. It doesn't give you any control over how intense the styles are, or how strong the light leak is, but it is easy

and effective. If you'd like more control over how your retro-feel will turn out, turn to Snapseed. It lets you choose between its more subtle Vintage effect or the more intense Retrolux feature. Both of them have a choice of styles and textures, and you can customize your light leaks in the Retrolux function.

Then you can make adjustments to brightness, saturation, and the strength of the style you've chosen, or the contrast, the depth of the scratches, or the intensity of the light leaks. Without resorting to Photoshop, it's the control-freak's best retro-fit option.

CROSS-PROCESSING & TOY CAMERAS

This decaying window-ledge seems a perfect candidate for some cross-processing fun.

#FLICKR #LOMO

#GOOGLE+ #CROSS

So you can spot a cross-processed image at 20 paces, with its peculiar color casts and strange contrasts—but do you know what gave rise to the effect? It's a film thing. Slide film needs to be developed using a particular combination of chemicals, while negative (print) film requires a different combination. If you start switching things about, and processing slide film with negative film's chemicals, or vice-versa, you've cross-processed your film.

As for toy cameras, they're not necessarily toys, just cheap cameras. Being cheap, they're often not properly lightproof—hence the light leaks in their photos—and their lenses tend to be soft and have unusual aberrations. If it all sounds a bit

familiar to a retro-toned photo, that's because it is!

Using a toy camera and cross-processing your films is a great deal of fun, but you can achieve similar effects using a smartphone, which is both faster and cheaper. Try Flickr's "Lomo" filter or Google+'s "Cross."

#FXCAMERA #MAGENTA (© Rachel Silverlight)

There's a huge number of apps available for creating a toy camera or cross-processed effect, ranging from those that simply let you choose from a range of set filters to apply, to those that give you finer control over the process. Lomo Camera and Camera FX will do the job nicely if you just want to apply a filter, but for the control freak it's got to be Vignette. Even the free demo version gives you access to an enormous range of filters, which you can then customize the look of to the finest detail—as well as allowing you to adjust the brightness, contrast, crop, and so on.

Vignette is a control freak's dream: as well as being able to adjust the basics, you can also tweak the filter to the minutest detail. #VIGNETTE

#LOMOCAMERA #DREAMY

PLASTIC BULLET

Looking further app-field, try Plastic Bullet for iOS. The process is completely random, so you have no idea what you'll get when it applies its filters, but that's part of the fun. And it's similar to actually cross-processing your film images; you'd never be sure how they'd turn out either.

#PLASTICBULLET

WARM & golden

A lot of photographers will tell you that the best time of the day to take photos is the hour around sunrise and sunset. That's because light at this time is soft and diffuse—rather than glaringly direct, which happens around noon—and everything glows. Whether you're taking portraits, landscapes, or photographing architecture, there's a magical quality to these "golden hour" pictures.

If your schedule doesn't permit golden hour photography, there are filters at hand! Try Instagram's "Rise"; Twitter's originally-named "Golden Hour"; "Iced Tea" from Flickr; or any of the options under Google+'s "Warm" filter.

#INSTAGRAM #RISE

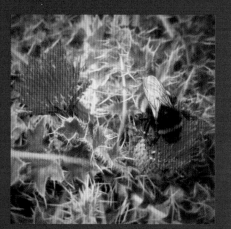

#FLICKR #ICEDTEA

#GOOGLE+ #WARM

COLORTIME

Rather than apply a filter, you might just want to control the tones in your photo, in which case I suggest that you crack out ColorTime. It lets you increase or decrease the shadows, midtones, and highlights in your images using a color wheel. This is far more nuanced than a filter and gives you more control over the final look of your photo.

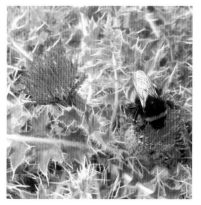

Under your control, you can create a subtler golden hour effect with ColorTime. #SUBTLE #GOLDENHOUR

WHETHER YOU'RE TAKING LANDSCAPES, *portraits,* OR PHOTOGRAPHING ARCHITECTURE

THERE'S A *magical quality* TO THESE "GOLDEN HOUR" PICTURES

cool & frosty

Snow on the Starlight, as I traveled from San Francisco to Portland.

#TWITTER

If warm and golden tones are so great for photographs, why would you want to do the opposite, and introduce cold blues and grays? For a start, they transform the mood of an image, and can create something somber and downcast. This can be excellent for some portraits, but works especially well for desolate landscapes, and makes wintry scenes feel even colder.

Instagram's "Hudson" is a witheringly cold filter. Use it to ice over your landscapes or make architecture look grimly corporate. Portraits can have a cold edge applied to them using Flickr's "SuperFade" or any of the selection of filters under Google+'s "Cool" option or Twitter's "Cool" filter.

Giving photos a chilly feel in Snapseed requires a few adjustments, but nothing

#FLICKR #SUPERFADE

#INSTAGRAM #HUDSON

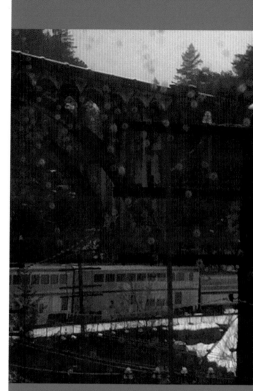

My own chilled version of my train ride, using Snapseed. #COOL

terribly complicated. In the Tune Image function, you need to reduce the ambience significantly, desaturate the colors slightly, and shift the white balance into the blue spectrum, which means adjusting to the left. You can alter the brightness and the contrast depending on the photo. Increasing the contrast will make it feel harsher, decreasing it will give a dull feel to your photo. That's it.

#GOOGLE+ #COOL

Contrast & KEY

Light, bright, and airy—it can only be high-key.

Even if you're unfamiliar with the terms "high-key" and "low-key," you'll probably be familiar with the effects. High-key is a product photography staple: it's bright and positive. Low-key is what you associate with horror films: dark and spooky. Both are low on contrast.

High-key photography is hard to recreate in post-processing, whether with filters or by hand. The majority of the work will have to be done "in-camera," with bright, even light and pale-colored subjects and backgrounds. You really need to have full control over your camera to get it right.

Low-key is for when you want things to be dark and mysterious.

Nothing says sinister more than a moody low-key image full of shadow. Keeping things on the dark side when you're shooting, perhaps including one bright spotlight is a great way to get the violins screeching in someone's head. You can give them a helping hand by playing with the contrast, toning down the brightness, and turning it black-and-white.

The unedited photo looks dull, flat, and uninteresting. (© Rachel Silverlight)

By simply increasing the brightness and contrast, however, the woods pop to life.

Filters make it easy to give some drama to a boring photo. #INSTAGRAM #XPROII

Increasing the contrast and the saturation in color photos is a winner for making them more dramatic, and when a photo is looking flat a few tweaks here can make all the difference. Just look at the improvement to the photos above.

In the first, unedited photo you can't see the woods for the trees, so to speak. After upping the contrast and saturation with Snapseed, the forest looks vibrant, and really much more as it did in real life. If you're not confident adjusting the

contrast yourself, many apps have auto-enhance features and filters to do the job for you. Instagram's "Lo-fi" is great for food, and "ColorVibe" in the Flickr gallery is strong on contrast too.

A little experimentation goes a long way, and many apps make it easy to achieve powerful effects with minimum effort. To show you just how easy it is, take a look at the third image. Here I used Instagram's automatic contrast enhancement, then I applied "X-Pro II,"

a high-contrast filter with a yellow cast. Finally, a radial blur adds even more depth to the scene, and gives a fairytale feel to the woods. All in three taps!

It won't work for every single photo, but utilizing these simple tricks should help you save a lot of images that otherwise would have been destined for the bin.

HEIGHTEN THE *drama!*

There's no clear definition of what constitutes a photo with a cinematic feel, except that when you see one, you'll feel as if it could be a still from a film. There will be something about the contrast and saturation, something about the way the photo makes you feel.

Filter-wise, there's no shortage of offerings to help give your photos a cinematic edge; Flickr even has color ("Brooklyn") and black and white ("Noir") versions. If you're using Instagram, look for "X-Pro II," or "Drama 1" and "Drama 2" in both Google+ and Snapseed.

City Road, London, UK, from the upper deck of the 205 bus.

#INSTAGRAM #XPROII

#FLICKR #NOIR

#SNAPSEED #DRAMA1

#FLICKR #BROOKLYN

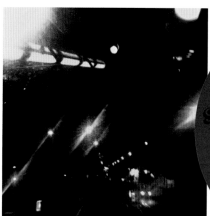

#GOOGLE+ #DRAMA2

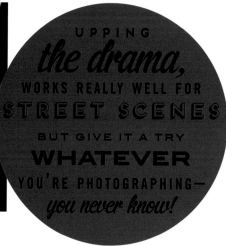

UPPING *the drama,* WORKS REALLY WELL FOR **STREET SCENES** BUT GIVE IT A TRY **WHATEVER** YOU'RE PHOTOGRAPHING— *you never know!*

Tilt-shift

Back in the days when films were developed in a darkroom, there were some effects and techniques that were only possible if you were fortunate enough to own specialist lenses or particular kit. The digital revolution has changed that and anyone with an editing suite and a bit of savvy can fake it. Tilt-shift is one of these effects.

I'm guessing that you don't want to know all the physics behind a tilt-shift lens, but a brief explanation is that it allows you to tilt the plane of focus in such a way as to either keep far more of your subject in focus than ordinarily possible—or to do the reverse and produce an extremely shallow depth of field, the like of which you wouldn't usually see outside of macro photography. The former is great for some landscape and architectural photography, but it's the latter use that we're going to concentrate on.

So why on earth would you ever want to limit your depth of field so severely? Well, primarily because it allows you to create miniaturized scenes, almost an optical illusion, where it looks as if toy cars are shooting through an intersection, or people frolicking on a beach are little ants. But, it can also add a wonderful whimsical effect to photos, too.

For a good miniaturized scene, you need a photo that you've shot from above: think boats from a bridge or rooftops from a skyscraper.

Then you need a tilt-shift effect: There's no shortage of apps for this—Instagram, Flickr, and Snapseed to name but three. In the following example I used Snapseed.

NOW YOU NEED TO:
1. Select between a circle-based or rectangle-based plane of focus

You want radial blur for circular subjects and linear blur for most other things. I've gone for linear here.

2. Position the point of focus.

Where do you want viewers to focus? I've chosen the center of the image.

3. Adjust the angle of the plane if you're using linear blur. Here I think I prefer it straight across.

4. Alter the width of the blur.

I've gone for something moderate here.

5. Adjust the degree of blur. Too much can be garish, so I'll tone it down a bit:

6. Adjust the brightness and contrast.

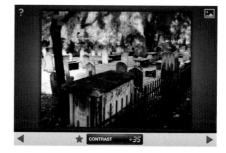

7. Up the color saturation.

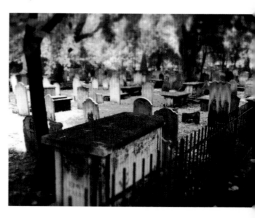

AND *you're done!*

Hipstamatic

Before Instagram was doing the square-framed retro-looking photo-taking thing, there was Hipstamatic. Hipstamatic came with a choice of "lenses," "films," and "flashes" that you digitally inserted into or attached to your camera to give your photos an old-school edge before sharing them in thoroughly modern way.

Whereas Instagram is a shoot-first-add-filters-later app, Hipstamatic requires a little forethought to decide on the best combination of lens, film, and flash if you need it, for your shot. You can choose between five lenses, four films, and three flashes that are bundled with your app purchase for that time-turned feel. If they don't give you sufficient options, you can spend some more pennies to augment your collection.

Since spring 2013, there has also been Hipstamatic Oggl, which is a "capture first" app. You can choose from five pre-loaded effects: food, landscape, portrait, nightlife, and sunset, to apply to your photos for free before sharing them in Oggl's curated feed or sending

I forgot about my toast. What can I say? #BUCKHORSTH1 #INAS1982

Poor bicycle! #JANE #KODOTXGRIZZLED

them straight to Flickr, Twitter, Facebook, Instagram, or Tumblr. If you subscribe to Oggl, you're given the keys to the entire Hipstamatic store of films and lenses and are treated to new toys every month.

Hipstamatic's free films are effect-neutral: the differences are found with the borders and corners. It's the lenses where you'll make the biggest impression. "Jane " is probably the most "normal" lens and, for me, "John S" has the most pronounced effects with its strong blue-green cast, high contrast, and dark vignette.

"Jimmy" gives everything a yellow tone, a soft, mushy look, and a bright vignette. "Kaimal Mark II" is low on contrast, but quite sharp, and gives your pictures a red cast. And if you want light leaks and grease splotches, try "Buckhorst H1."

The three flashes that you can use for free are the standard flash, the "Dreampop" flash that gives you randomly selected color flares for a "Polaroid" look, or the warm-toned "Cherry Shine" flash.

And for those moments when making a decision is far too much like hard work, *shake your camera* and you'll be presented with a **RANdOM COMBINATION!**

Mmm! Gooseberries! #JIMMY #INAS1969

A freelancer's life! #JOHNS #INAS1982

A different take on a freelancer's life! #KAIMALMARKII #BLANKO

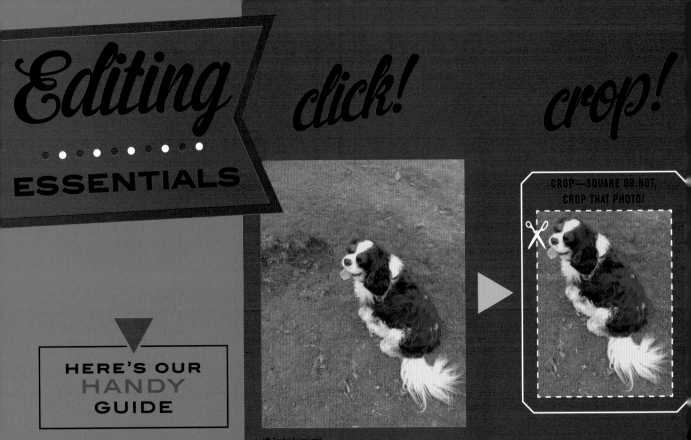

Editing
ESSENTIALS

click!

crop!

HERE'S OUR
HANDY
GUIDE

CROP—SQUARE OR NOT,
CROP THAT PHOTO!

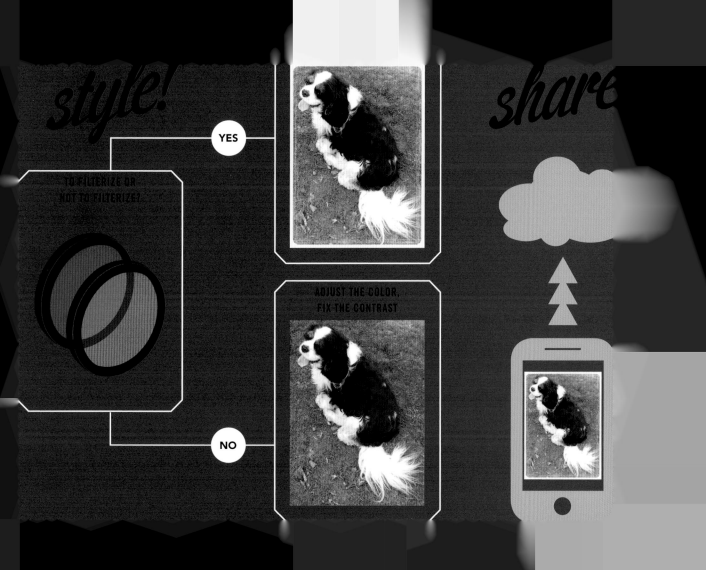

Master's Tips

Getting the most out of your smartphone camera is easy when you know how. What you need to remember is that different situations are going to require different approaches. With these fail-safe tips, you'll not miss a photo opportunity again!

There's something intangible that makes a portrait sparkle; it's being able to capture someone's spirit. It's not so much stealing an entire soul, but instilling the essence of it into your photos. And with the eyes being the windows to the soul, it starts with those.

It doesn't matter if someone is wearing sunglasses or is doing her or his best Cousin It impression: the eyes (or where the eyes should be) must be in focus. Humans are automatically drawn to other people's eyes, so it'll be the first place someone looks in a photo. If the eyes aren't in focus, you'll have lost your audience's attention almost immediately.

So often I see portraits where the subjects are halfway down the frame with huge gaping expanses of not-contributing-very-much-to-the-photo background drifting aimlessly above them. Get closer! Fill your frame with your subject; the photo is meant to be about them, so make it all about them!

Remember the rule of thirds from page 54? It works a treat for portraits. If you aim to place the eyes on the upper triline

THE CARDINAL RULE
OF
portraits
IS TO GET THE
EYES
IN FOCUS
AFTER THAT
everything else
IS NEGOTIABLE

TOP
TIP
Tap on your screen to secure your point of focus.

you'll make sure your subject is filling your frame. Whatever your composition, try to have at least one of the eyes on one of the points of interest.

Mix up your angles. Photographing someone straight on has the potential to be boring. A slight turn of the shoulders makes things interesting. Taking photos from the side can give your pictures a photojournalistic feel. Shoot from above and you'll make your subject look tentative and unthreatening; shoot from below and you'll make them look empowered or even intimidating. Posture and expression count for a lot here too.

The hours around sunrise or sunset are the best time to take any type of photo, and certainly portraits. The light from the sun is warm and golden and the shadows are soft. Your subjects will glow. Where possible, try not to use your flash because it can gives people unflattering shiny patches, and avoid shooting when the sun is high in the sky because it casts harsh shadows. Unless you're going for a dramatic look, try to light your subject as evenly as possible. And don't forget to adjust the white balance!

Finally, capturing people candidly, or at least not making them pose for your photos, almost always means a more natural, more relaxed photo. And that's when you capture spirit.

Be ready to capture a dynamic pose.
#CANDIDPORTRAIT (© Frank Gallaugher)

Remember Your camera has a wide-angle lens: you don't want to give people unnecessarily large noses!

Selfies

Work your angles for a good selfie.
#SELFIE #ANGLES

Just me. #SNAPSEED

We've all done it. We've all held a camera out in front of us, lens toward our face, and tried desperately to take a halfway flattering photo. Often we fail. We look bored because our eyes aren't looking at the lens, or we've given ourselves double-chins, or you can see straight up your nose. Thankfully, it doesn't have to be this way.

First things first, look at the lens, not at the screen. It can take a bit of training to convince yourself not to look at the screen. If you're taking the photo, it's the instinctive place to focus. Don't! Everything will be fine for the split-second when you look away from the screen and at the lens.

Check your lighting. You don't want shadows as dark as caves (usually cast by a very bright, high light) or blinding shiny patches (normally from strong, direct light). If you shoot with very bright light behind you, you'll likely end up with a silhouette. I love silhouettes, but they're not what you always want. Artificial lighting often gives your shots an unflattering color cast; natural, even light coming in on a diagonal is your best bet.

Me enjoying the sunshine. #SELFIE #RETRO

ACCESSORY ALERT!

**You can try balancing your
smartphone on its side or leaning
it against something for hands-free
photography, but stabilization
devices for smartphones are pretty
inexpensive. I'm a fan of the Tiltpod
and of Griptights.**

Look behind you! When you're taking a photo of someone else, it's easy to see if the background is working or if she or he is going to have a streetlight growing out of her or his head. You don't have eyes in the back of your head, so turn around and have a look.

Back in the old days of point-and-shoot cameras you used to be able to set a timer on your camera so that you could press the shutter release button, run like a speeding train into your shot, take a breath, and almost compose yourself before it took the picture. Your smartphone camera might not have a delayed shutter mechanism, but it can run apps that do.

I'd recommend either Triggertrap, which you can trigger when you're in position by making some kind of distinctive noise, such as clapping your hands or whistling, or Gorillacam, which allows you to set a delayed shutter of between one second and two minutes. Both are free and both will give you a lot more flexibility.

A self-portrait doesn't have to include your face. True, pictures of feet might've been overdone, but I've been taking them for years and I'm not about to stop now. My glasses have become a favorite pseudo-me in recent times, though!

DON'T TRY TOO HARD. DON'T TRY TO PULL A SEXY FACE, OR TRY TO LOOK COOL: *just be.*

Clearly my niece knows how cool she looks in a pair of aviator sunglasses! #NIECE #POUT

In many respects, taking photos of babies and children is just like taking photos of fully-grown subjects: get the eyes in focus, fill your frame, and check your lighting. But in many other respects, it's not. Your prize shot is going to come because you spent hours sitting on the floor amidst the chaos of toys and paint and little bits of cut-up paper, waiting for it—or because you turned around and it

was right there in front of you. Patience or dumb luck: either will work.

The bit about sitting on the floor? It wasn't added for effect. Getting down to kiddie-height will yield better results than imperious strutting. First, little people will respond better to you when you're on their level; second, the angles in your photos won't look so condescending. I do have some cracking photos of my nieces and nephews that I've taken from above, but they're usually great because they're stylized. The rest? I've been sitting on the floor, kneeling down, or crouching.

Little kids might be best photographed when they're active; babies, on the other hand, are best photographed when

How could that look not be captured? #INTHEMOMENT (© Chris Gatcum)

The best shots of children come when they don't know that they're being photographed. No cheesy grins and no awkward poses, just glorious, childlike joy

The best view: Up close and sitting on the floor! #GETCLOSER #GETDOWN

they're sleeping. Look for that soft, even light falling through a window and wait for them to do the cute things that babies do: yawn, screw up their faces, sometimes suck their thumbs. Or wait for the moment when they're looking angelically serene. Vary your angles around the baby, but make sure you don't take a picture looking right up their nose. And don't forget to capture the details up close: baby eyelashes, tiny feet, and button noses.

Sleeping babies pulling high fives (or stopping traffic)? Not much is cuter! #CUTE (© Natalia Price-Cabrera)

TOP TIP:

Take lots of photos. It's not just that kids move so fast you never know what you might capture, but in the grand scheme, they grow up so fast and you don't want to miss anything.

PUPPIES, *kitties*

How cute? #KITTEN (© Haje Jan Kamps)

Photographing animals is alarmingly similar to photographing children. It's a question of either patience or dumb luck, and capturing them in their environment, behaving naturally.

There are millions of photos of cute kitties, puppies, and bunnies floating about on the internet. If you want your photo to stand out, you have to capture your pet doing something obscenely cute or ridiculously funny, but not contrived and definitely never cruel. You know your pet best, so it will be a case of watching,

waiting, and snapping. Just like any other portrait, make sure the eyes are in focus, get in close, compose the frame properly, and be aware of your light.

Now, I'll admit that I'm not convinced of the merits of a smartphone for safari photography, but there's nothing to stop you from using one to capture wild animals. In particular, they're great for taking pictures of insects.

When you're photographing insects, you need to be close and you need

ACCESSORY ALERT!

If you want to get really close, you can buy macro lens attachments for your smartphone.

My favorite is the Easy Macro—a macro lens on an elastic band!

to be quick. By being quick, I mean that you need to be ready to release the shutter in a moment and that you need a fast shutter speed to capture your ladybird unblurred by motion. The only way to ensure a fast shutter speed with a smartphone is to make sure that you have a lot of light on your subject. By being close, well that's quite obvious. The problem is that by being close you often obscure your light source. The answer is to think about your angles carefully when you're padding around a flower bed!

Shooting from down low meant that I didn't cast a shadow on the cabbage white butterfly. #BUTTERFLY #ANGLES

Remember

While you should never try to engineer photos of wild animals, if you're lucky enough to capture a ladybird on a blade of grass or a bumblebee in a purple flower, they will look stunning. It's all about the color contrasts.

All photography is about telling stories, but the time you really need to get your storytelling gig on is when you're taking photos at a party or wedding. Or at any kind of event, really. Every photo needs to capture a moment and preserve it for posterity, for the people who were there and for the people who weren't.

Obviously you'll want to capture the big moments at a wedding—the first kiss, the cutting of the cake, and the tossing of the bouquet—but be on the look out for the quieter, the candid, and the often-overlooked moments. Watch out for subtle glances, the people who might not always be photographed, and for the children hiding beneath a table with a plate of cake.

Remember

If you are permitted to take photos during a wedding ceremony, turn off the flash!

PHOTOS OF *parties* AND *weddings* SHOULD NEVER HAVE THE SENSE OF *"you had to be there"*

THEY SHOULD MAKE YOU FEEL AS IF YOU WERE THERE

Toasting the bride and groom is all-important! #CELEBRATE

The devil is in the detail. #DETAIL.

Don't forget the details, either: the table decorations, the favors, the buttonholes, and the bridesmaid's shoes.

The same goes for parties. If it's a themed party, capture the decorations and the costume details that make the event special. A variety of close-ups and shots that show the context and action will be far more effective in telling the story, and more interesting to look at as well.

Not being a huge fan of posed photos, I'm always on the look out for people animatedly recounting stories, or the unlikely couple tangoing on the dance-floor, or for the person trying to squash an entire profiterole into her mouth in one go. When I do need a posed picture, I try to avoid anything too formal—parties are meant to be fun, after all.

Anticipation is key—you've got to be ready with focus and exposure preset if you want to capture a candid moment at the height of the action. #ANIMATEDSUBJECTS (© Frank Gallaugher)

Remember

Parties are meant to be fun. You need to enjoy yourself, not always be taking photos. And not everyone likes being photographed so be careful not to make anyone feel uncomfortable.

Smartphones' small sensors are a blessing and a curse: a blessing for their ubiquity, and a curse for their terrible low light capabilities. If you requisition the help of a friend and another smartphone, however, you can do something about their poor late night performance.

Unless you're absolutely desperate, you're best to avoid your smartphone's flash. They tend to be harsh LED lights and they're located so close to the lens that it's a sure-fire way to get evil red-eye.

For some shoots, a professional photographers might want to make sure that their subject is perfectly lit, using a serious megawattage of external flash or lighting that can be moved and manipulated to get the precise look they want. You can do the same thing—at least in principle if not scale—with your friend and her smartphone.

Download one of the thousands of light and torch apps onto your friend's smartphone, fire it up, and experiment! Two friends with two smartphone lights will mean double the fun!

CAMERAPHONE ONE

CAMERAPHONE ONE IS THE CAMERA AND IT'S IN YOUR HANDS

CAMERAPHONE TWO

CAMERAPHONE TWO IS ACTING AS THE LIGHT SOURCE AND IT'S BEING WIELDED BY YOUR TRUSTY ASSISTANT

Without any flash the subject is virtually invisible.

With direct light from the phone's built-in light the subject is flat and suffering from the evil red eye.

With a light held to the photographer's side the light falls more softly on the subject, and he doesn't have devilish eyes!

Now you get to direct your friends, or "assistants," to move their lights so that you get the effect you want. Try closer and farther away, vary your angles, and look at the different shadows the lights cast. You can go for soft, gentle lighting, or try creating stark, dramatic shadows.

A SNEAKY USE FOR FLASH

Have you ever seen a gorgeous flower emerging from a black abyss and wondered how the photographer managed it? It's pretty simple, actually. It requires lighting the flower so that it's brighter than the ambient light. You can do this with your flash in daylight. Nifty!

Alien strawberries emerging from an alien hand! #FLASH

DID YOU *know?*

Red-eye is when light from a flash is reflected off the eye's blood-rich retina and straight back into the camera's lens. It's angle-dependent, so you normally see it when the flash is positioned close to the lens.

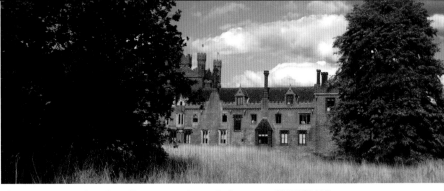

The gorgeous Oxburgh Hall emerges through the trees. #LANDSCAPE

Have you ever looked out at a stunning view, thought, "I have to photograph this!" and then been utterly disappointed by the results? You're not alone. Transferring what you see and feel to a photo is curiously harder than you think. But be disappointed no longer! Here are five steps to making your landscape photography a success.

1: STORY

Any photograph starts with a story, it's what helps your audience connect with the image, and landscape photographs definitely need a story. What is the solitary person thinking? Where does the river lead? Who built that barn right there? Make sure that your landscape says something!

2: LIGHT

Harsh midday light will do nothing for your landscapes in a photograph. You're much better capturing them around sunrise or sunset, as the light in the hours around them is much more forgiving. If the color of the light seems to be coming out wrong in your photos, try adjusting the white balance.

3: COMPOSITION

Remember the rules of composition we looked at earlier and make sure your horizon is level. Don't forget about the edges of the frame—what's happening there is just as important as what's happening in the center. Picasso didn't ignore the corners of his canvases and neither should you!

Landscapes don't have to have a horizon! #LANDSCAPE #TRAVEL (© Haje Jan Kamps)

TOP TIP

Activate the grid overlay to help you compose your landscapes.

4: EXPOSURE

Achieving a good exposure in a landscape can be tricky; there are so many differently lit areas comprising the scene. Try exposing for the sky, because it's easier to fix under-exposure than it is over-exposure. If you think that you might really struggle with variations in contrast, try your smartphone's HDR function.

5: SENSE OF SCALE

Anything that can provide a sense of scale to your landscapes will help to bring them to life. It can be a cow in a field, a solitary water tower, or an abandoned vehicle: All it needs is to give viewers a point of reference that they can use to lever themselves into the photo.

Follow me, across the meadow and beyond the trees. #LANDSCAPE

The horizon may be centered, but note the use of leading lines. #BREAKTHERULES

Remember

Landscapes don't have to be of the countryside—the urban landscape can be just as compelling.

105

& TINY
planets

Choosing definite elements to anchor your panorama at either end makes the final frame much stronger. #PANORAMA (© Frank Gallaugher)

When I was growing up, I remember my father's endeavors to make panoramic images of the stunning scenes from cliff- or mountain-tops. It would involve him taking almost a reel of images, hoping that he hadn't missed any areas in his sweep of the view, and then us laying out the photos (once they'd been developed) on the kitchen table to assemble the finished image. Things are a whole lot easier now!

Lots of smartphones have a dedicated panorama mode and if they don't, you can choose from a welter of panorama apps. You fire it up and follow the instructions to take a series of images that it stitches together to create a vast photo. It really is that easy. But a few tips for doing better can't hurt, can they?

1. Choose where you're going to start and where your panorama will end before you begin filming. Envisage how the finished panorama will look from where you're standing.
2. Unless you're going for a deliberately dramatic photo, look for even lighting.
3. Stand still! If you have a stabilization device, you might want to use it.
4. Check your composition—where do you want the horizon?

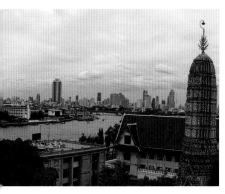

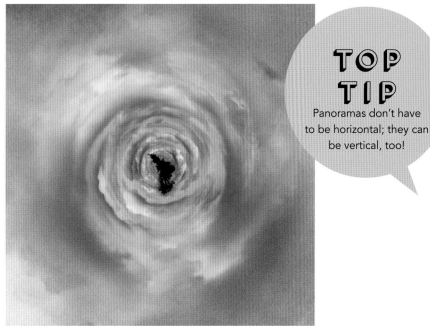

TOP TIP

Panoramas don't have to be horizontal; they can be vertical, too!

5. Sweep your smartphone slowly and steadily, following the arrow on the screen. This will help you get a proper overlap between your images so that they can be stitched together effectively.

If you want to move away from the traditional panorama, try a tiny planet. Instead of showing landscapes with a traditional straight horizon, a tiny planet has a circular horizon. You can make them from any landscape shot, but it will work best if the top and bottom areas of your photo doesn't have too much detail. It's especially essential to get a level horizon here, as the edges will be joining up.

The predominance of cloud and sky in this photo has created a vortex-like feel. #TINYPLANET

Remember If you don't have something to stabilize your smartphone, hold your elbows into your abdomen to help keep your smartphone steady.

REAL-ESTATE & ARCHITECTURE

It might not look quite like this every day, but if you want a property to look appealing it's going to have to be tidy! #REALESTATE (© Rachel Silverlight)

Let's be honest, if you're selling your ocean-view mansion worth millions, you aren't going to be taking photos of it yourself on your phone. But if you need a few photos of your spare room to rent it, or to show off your new pad to your friends, your smartphone is perfect.

Here's what you need to do: Turn on all the lights and make the most of the natural light from the windows too.

Standing back far enough helps to eliminate the convergence of vertical lines, or the keystoning effect.

The light patterns; the architecture; couldn't resist! #ARCHITECTURE (© Haje Jan Kamps)

Make sure that all the lines in your photos are straight—no one wants to see bowed walls or crooked window-frames. Always shoot into the corner of a room, never flat onto a wall. Make sure that the room is de-cluttered, and don't forget to give your photos a quick edit. But you're doing that to all your photos, aren't you!

When you're photographing a building from the outside you're likely to encounter two problems. First, other buildings have an irritating habit of getting in the way. Second, what you were certain was a perfectly upright structure in real life appears to be leaning backward in your photos. That effect, known as "keystoning" is caused by a convergence of vertical lines and it happens because you tilt your camera upward to capture all of the building in one shot. The solution? Move backward. No, that's not enough. Back some more. You need your camera to be perpendicular to the building's front. Across the road if you have to. There!

But, if you don't need a perfect exterior shot to convince someone to rent your two-bed apartment—say because you're photographing a cathedral—I propose a far more radical solution. No, it doesn't involve a wrecking ball.

GET REALLY CLOSE
Stand practically at the foot of the building, embrace the wide-angle, and shoot upward. Trust me.

No distracting roads, streetlights, or background traffic, just the clock tower against the blue. #LOOKUP

day-to-day

Where the smartphone really comes into its own is capturing the everyday. It's sitting there, in your pocket or bag, waiting to record and share those things that catch your eye. Whether it's a cake so beautiful you're not sure how you can eat it, an eggplant so large it defies belief, or a randomly abandoned sink that leaves you wondering how it got there, they're all there for the taking.

COMPOSE:

Take your time when composing your shot. Think about the best place in the frame to position your subject, and the angle you're shooting from. And don't neglect the background or the edges of the frame—they're important parts of your photograph too!

1. Get closer.

2. Think about your angles: move your camera around and move yourself around to find the best possible shot.

3. Check the background: clear the clutter from behind plates and make sure there isn't an overflowing trashcan hanging about in the frame.

Two factors are going to affect your photography of the serendipitous things that crash and drift and pass through your life: time and light. You have more of both than you realize, but you need to make use of them properly.

Strange, the things you see on the way to the allotment. #ABANDONED #EVERYDAY

I was crawling around on the floor to photograph this bee, making sure that I was close enough, the angle was right, and the background worked. #PATIENCE

You can see from the very bright edges that I was deliberately shading these zucchini from overexposure. #SHADE #EVERYDAY

EXPOSE:

Where is the light coming from and what type of light is it? Judging the light accurately will make a difference between a photo that you'll want to share and a photo that you delete.

1: Direction. Unless you're going for a dramatically lit photo, you want even light rather than anything bright and direct that leads to nasty shadows, glaring reflections, and overexposure. Try not to photograph into the light or to stand in the way of your light; watch out for unwanted shadows. However, do not underestimate the usefulness of coming between your subject and your light source to block very bright light. And when you're outside, shade is your friend.

2: Type of light. Almost anything benefits from being photographed in natural light, but food especially. If you can, move things toward a window, and whatever you do, avoid the flash when it comes to food. A pulse of bright light will do your

Roasted rhubarb ready to be made into trifle. Yum! #PATTERN #EVERYDAY

griddled zucchini with yoghurt and mint dressing no favors at all.

After that, it's about keeping your eyes open for the interesting and unusual!

TOP TIP: Give your lens a quick wipe before you take a photo. The dust, fluff, and grease it will have accumulated in your pocket or bag won't do much to enhance your photos!

FARTHER
afield

Even if you think that a trip to a far-flung and exotic destination (or a quiet weekend away at the seaside) is the time to bring out your DSLR (which it might be, if you have one), you may find there are times when you'll still want to use your smartphone.

For a start, smartphones mean instant sharing; and instant sharing means instant envy. Why wait to show people how luxurious your hotel room is and how beautiful the view? Do it straight away!

A quick photo is an easy way to update your family and friends still at home as to where you are and how you are, and let them experience the moment with you even if they're not there.

Phones are also great for capturing the small things, the things that happen in the moment, but really do need to be shared. And shared quickly, of course.

And, of course, smartphones are discreet, so they're perfect for capturing photos when you don't want to be conspicuous with a big camera.

"Official mission?" My immigration card for Indonesia tickled me; it had to be shared! #TRAVEL

Be sure to get some human action photos on your trips—a travel album full of only architecture and landscape shots will end up feeling like a stack of postcards.

(© Frank Gallaugher)

Always get a window seat! (© Frank Gallaugher)

Hawaii in December. #TRAVEL (©Matthew Dean)

If you're worried about connectivity when you're far from home, even the most remote and isolated places often have some semblance of Wi-Fi; it shouldn't be too much of a problem. And for those times when there isn't a shred of access to be had, there's "Latergram"— or saving your photos to share at a later date, when you're back on the grid.

It doesn't matter what type of camera you use for your travel photography, what matters is the story that you tell with the photos you take. Look out for the unusual, for the things that might be considered inconsequential, for the elements that convey how you're a stranger in a strange land. As well as the grand sweeping vistas, keep your eye out for the details that convey a sense of place. When you look back at your photos, you want to feel as if you're right back there in that moment.

Waiting for my cousin at a restaurant in Perth, Western Australia. #TRAVEL #MENU

Remember In some cultures, taking photos of people or of holy places is taboo. It doesn't matter if you do it with a medium format camera or a smartphone, it will still be off-limits.

MAKING
movies

Still images are great, but every now and again you need something a little longer and a little more animated to be able to tell the story. What you need is a video clip. Step forward Vine, and Video on Instagram.

Vine is a Twitter-integrated app that allows you to make and share six-second videos that play in a loop. Video on Instagram doesn't loop, can last up to 15 seconds, and has a choice of 13 filters you can apply to your cinematic masterpieces.

If this all sounds a little restrictive and contrived, you can say a whole lot more in six seconds than you think you can, and some people have truly made an art of the form. Really, for on-the-go communication, you don't want a video to be much longer than what these apps allow. Go on! Give it a go! I'll even give you some tips.

WHAT YOU MUST DO:
1. Decide what you're trying to say before you start to record—making it up as you go along very rarely yields good results.

The green bar shows how long you have recorded for, and how much recording time you have remaining. #VINE

2. Your time is limited, so use it wisely and don't try to say too much.
3. Keep stable: If you want to include panning, make sure that it's smooth.
4. Think about your composition: Vines and Videos on Instagram are both square.
5. Check your lighting—yes, this makes me sound like a looping Vine, but light is everything in photography; nothing too harsh, and no obfuscating shadows.

Check your video before you post it.

Name your video, add a #hashtag, and unleash it on the world.

Watch your video again, and again, and again... #LOOP

WHAT YOU NEED TO REMEMBER:

1. You can't fix the white balance: Unlike a still, you can't head to an editing suite to make everything less blue, so if you want to change the lighting, do it first.
2. Your video will be recorded with the autofocus. You can tap to set the focus before you start to record, but after that, it's all down to your camera.

WHAT YOU CAN TRY:

1. Stop motion: Set up your scene, tap the screen to record one frame, reposition your subjects, tap the screen to record another frame, repeat until you've completed your animation.
2. Transitions: Cover the screen with a piece of paper during recording and then remove it to produce a transition effect.

Vines are shared on Vine (obviously) and you can choose to send them to Twitter and Facebook, too. Don't forget to caption them properly and use some hashtags. Video on Instagram is shared just like any other Instagram. Simple!

Chapter 5

Who are the movers and shakers in the world of social photography? Some of these people, that's who! If it feels a bit peculiar following people you've never met and with whom you have no relationship, remember that you do have a relationship. It's photography. When you find someone whose photography gives you the shivers and leaves you wanting more, click the button and follow them. It's the same as having a gallery of images directed to your smartphone. What can possibly be wrong with that?

Allison Smith

Allison is a writer from the USA, but right now she's on the road, traveling through Oceania and South East Asia. Her only photographic tool is her iPhone!

NAME: Allison Smith
LOCATION: Wherever she can find the cheapest ticket
DEVICE: iPhone

Documenting all of her travels using Instagram kills two birds with one stone for Allison: it's a travelog where she can combine her writing and her photography. And of course, iPhones are discreet and portable when you're on the move. That said, she's noticed that most of her fellow travelers take at least two pictures wherever they are: one with a traditional camera and another with a smartphone. "The image on the phone goes directly to a social network, a mark of where the traveler is standing right this instant, and an update for worrying mothers across the ocean." They are, effectively, postcards.

Even though a smartphone might be a camera in "just a phone," which can give its photos a more frivolous feel,

Kuala Lumpur, Malaysia. Malaysia is a great place to find perfect symmetry, degraded over time.

Captured in northern California, USA. I couldn't resist the kitschy Americana in the matching bright colors of this scene.

Captured in Bangkok, Thailand. It took a lot of patience waiting for the dog to be in perfect alignment with the stairs.

Penang, Malaysia. Cuisine—and the way it's presented—is an important part of how I experience other cultures.

Allison is careful to abide by the same code of ethics that she would adhere to if she were shooting with her DSLR. "Smartphone photography is still photography," she says.

Allison doesn't have a favorite Instagram filter, and she doesn't always feel the need to apply one. What she does always do, however, is edit her smartphone images as she would if she had taken them with a DSLR and were tweaking in Photoshop on a computer. For that, her preferred program is Afterlight.

FINAL WORDS OF WISDOM: "I've made some great connections just by using Instagram to point out to locals that I'm shooting in their city or town."

👉 **INSTAGRAM:** allisonsmithers

Melbourne, Australia. I love when street art changes the atmosphere of an ignored alleyway. This replica of The Great Wave off Kanagawa crashing over city trash is painted on the back wall of a strip club.

★ **ALLISON'S ONES TO** *watch*

Allison's favorite Instagram feeds belong to young people who share tiny images of the beauty in their ordinary, daily lives, along with a bit of charm in their observations and words:

joshuakimchi
zkac
bart0lomeus

Bruno is a biologist who lives and works in Brasilia, Brazil, but he was born and grew up in a small town close to the sea in Espirito Santo state. It was upon moving to Brasilia, far from his family and friends, that he took up photography as a hobby.

NAME: Bruno Coutinho
LOCATION: Brasilia, Brazil
DEVICE: Samsung Galaxy SII

If one word could summarize Bruno's relationship with social photography, it's "liberation." Film photography was expensive and time-consuming, but the digital revolution allows us to take as many photos as we want, delete, and shoot again infinitely. "The ease of taking a camera with you everywhere in your pocket has redefined photography."

Not only has smartphone photography opened up the medium to the masses, but it has given it a less formal edge. As Bruno says: "It allows me to dare more." To this end, he loves to use filters. His favorite Instagram filters are Mayfair and Lo-fi, but he likes the Snapseed app, too.

BRUNO'S ONES TO *watch*

They're all Instagrammers:

gabriellordello
sardinha17
jaynieannie
ticianaporto
soarests
kab_s

Bruno shares his work across a spectrum of social networks: "I show my pictures, I see the work of others, appreciate it, think about it, learn, and try to improve my work a little more each day."

FINAL WORDS OF WISDOM: "Don't worry about having the latest model of smartphone. A good photo will be good with any camera. You make the photo, not your smartphone. Don't be shy to shoot; be bold."

FLICKR: www.flickr.com/photos/coutinhobr/
INSTAGRAM: coutinhobr
TWITTER: @coutinhobr

Bruno Coutinho

Boat photographed in Brasilia Zoo.

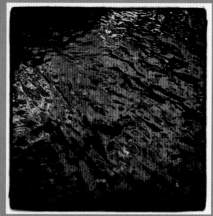

Reflection of a house on the water.

A simple composition with a coconut and a broken chair.

Red wall with fire signal, photographed at an airport.

Ceiling of a red dining car of a train.

Brazilian colors and plenty of texture in a small boat.

Darren lives in Cornwall, UK and is a project manager for a leading web agency. He's lucky enough to have both lived all of his life in the gorgeous South West of England and had the opportunity to travel and see much of the world.

NAME: Darren Shilson
LOCATION: Cornwall, UK
DEVICE: Samsung Galaxy SIII

Although Darren engages with lots of different social media, you'll find most of his work on Flickr and Google+. He's had a Flickr account since 2007, so it serves as both a showcase for his work and as an archive. This archive demonstrates how far he has progressed photographically and traces the maturation of his style; and because his phone is always with him, he can use it to help capture the places he visits: "It's fun to see that I'm here one day and there another."

Social photography doesn't just chart Darren's photographic exploits, but it helps to shape them, too: "As I'm continually defining my own individual style, social photography is a great way to test things out and with the valuable

My first Instagram image and probably my most famous one. It's been used in blogs, both for and against Instagram.

I call this Fortress Beach and it just sums up many Cornish beaches in 2013.

These two images were both captured with a DSLR and Instagram'd—it might be cheating but I recognize the massive potential of Instagram as a platform for my work.

The Cornwall Cross greets many visitors to Cornwall. The colors of the structure contrast really well with any sky.

Capturing the unexpected, as the tide went and myself and my children came across these huge Hermit crabs.

DARREN'S ONES TO *watch*

Michael Levin
Joel Tjintjelaar
Russ Barnes

feedback I've received especially in the last year or so it's helped me immensely."

When it comes to using filters, Darren prefers those that add depth and contrast to his photos. His favorites are Nashville, X-Pro II, and Lo-Fi. And being a "sucker for cloudy skies," he likes the filters that can help to enhance them.

FINAL WORDS OF WISDOM: "The key thing is to look up, look around and capture the world. Capture sunrises and sunsets, capture nature alongside the fun things, our only boundaries are those placed upon ourselves, by ourselves."

FLICKR: www.flickr.com/photos/ darrenshilson

Ian Robins

Ian lives in Bristol, UK, which he finds a great inspiration for his photography. His day job is in marketing.

NAME: Ian Robins
LOCATION: Bristol, UK
DEVICE: iPhone

There are two motivating factors behind Ian's use of social photography: first, to capture and share experiences that family and friends can see; second, to discover new places and find inspiration from others. He uses Twitter, Flickr, Instagram, Google+, and Facebook, and thinks that Flickr and Google+ offer great ways of sharing and interacting with photos.

Sometimes Ian adds a filter to his photos and sometimes he doesn't. He finds that they can add personality to an image, or emphasize a point of focus. As for his favorites, they're Amaro and Mayfair, both from Instagram.

When I asked him what he thought the impact of smartphones had been on photography, he was unequivocal about accessibility: "You always have a camera with you that's easy to use.

While on holiday in Devon, I noticed these clouds from the beach. I love the light and the shapes of the clouds. I used the Flickr app for this.

I see so many people using their phones to take pictures. Many are considering the photo they are taking and carefully editing to capture a moment or express their creativity. Some may feel it makes photos more disposable, but photos that capture people's imagination do have a longer life."

FINAL WORDS OF WISDOM: "Use Instagram or Flickr. They do most of what you need in a single app. The Flickr app offers more editing options than Instagram. You can always try other apps as you want to add more creativity."

This photo really summarized a recent trip to San Francisco—beautiful trams and amazing weather.

This photo was taken on a commute to work. I also love the colors of cherry blossom trees and this was no exception.

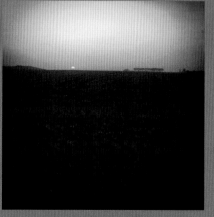

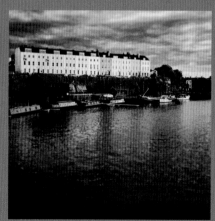

I love the feel of this photo capturing the view toward San Diego.

I pulled over to take this picture of a sunset over Bath's countryside. The trees in the distance just looked perfect.

I was walking home from work when I saw the evening's sunset on the river in Bristol. I just had to capture it!

Isabel Malynicz

Isabel lives and works in London, UK, but was born and raised in Papua New Guinea. When she isn't taking photos, she works in Human Resources.

NAME: Isabel Malynicz
LOCATION: London, UK
DEVICE: iPhone

Being a frequent traveler means that the majority of Isabel's photography has a social element to it: she uses her smartphone to capture the essence of where she is and to share it in real-time so that other people can enjoy it. You'll find her photos on Facebook, Instagram, Travelpod, and Twitter.

Using a smartphone means that taking a photo is a quick and non-intrusive process. There's no messing about with camera cases and lens caps and she's more likely to capture a natural shot or something that is fleeting.

Isabel's opinions on filters is a resounding "Yes!" As she puts it, "Why not make the world a little brighter?" Her favorite filter is Instagram's X-Pro II.

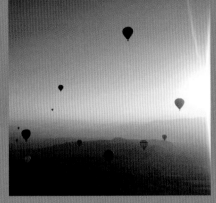

Hot air ballooning as the sun rises in Cappadocia, Turkey; it's something everyone should do. This shot captures the serenity of the moment.

FINAL WORDS OF WISDOM: "Use filters, but wisely. Sometimes natural colors are better. Composition is key—just because you have digital technology at your fingertips don't lose sight of the fundamentals of good photography. Delete your unwanted pictures frequently and don't forget to back up!"

INSTAGRAM: izwhizz

Wildebeest and zebra in Serengeti—I was surrounded by others that had the latest SLRs, but this photo goes to show you don't need fancy gear.

Double rainbow in Chamonix—an example of not having time to search for my DSLR. The rainbow had gone in less than five minutes.

Where else but Italy would you find Rosaries being sold in a vending machine!

Seville bullring. You don't need to see the bull to imagine the drama!

good composition IS ABOUT ANTICIPATION, TIMING, AND CONSCIOUS DECISION

VISUALIZE THE IMAGE YOU WANT TO CAPTURE FIRST, THEN WAIT FOR THE *perfect moment* WHEN ALL THE ELEMENTS ARE PERFECTLY PLACED

Leon Neal

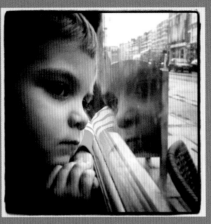

Max watches the world from the window as we finish our coffee.

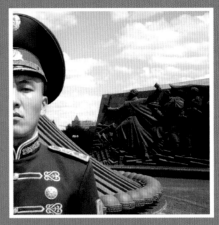

A soldier of the Kazakhstan army stands to attention at the the "Monument of the Motherland Defenders" in Astana.

Leon is a staff photographer for the international news agency Agence France Press. Originally from Sheffield, he now lives in London.

NAME: Leon Neal
LOCATION: London, UK
DEVICE: Blackberry Z10 (with techno-shenanigans to get Instagram installed)

The chances are that even if you don't use Instagram or follow Leon on Twitter, you will have seen one of his photographs before now. They regularly feature in major news publications, both in print and online. But the social element of photography is important to him, too: "Sometimes, I just want to share a moment or something that I've found funny. However, on larger news stories, I will often share what I consider to be more "disposable" pictures via Instagram and Twitter."

As someone whose living is derived from taking photos, Leon talks very

★ **LEON'S ONES TO** *watch*

Find them on Instagram:
mmordasov for his on-going essay on daily life in Sochi, Russia
philmoorephoto for his work from Africa
robstothard for his documentary-style of photography
alex_ogle for his photos of daily life in Hong Kong

Police officers shelter from the rain, while members of the media wait for their first view of Prince George.

A view from the top of City Hall, as city workers and sunbathers enjoy the sun's warmth in "The Scoop", central London.

candidly about image theft: "If it's online, it will get used by someone. It's up to you whether or not this upsets you." If you're worried about your photos being stolen, you really have two options: don't share your photos, or share your photos, but watermark them using an app like Marksta. Of course, you can be discerning about the content you choose to share: "I don't believe in putting valuable content on a platform that has very little image security."

Smartphone photography has been a double-edged sword for people's perceptions of photographs and photography, in Leon's opinion. It has made it accessible and effortless for people to take sharp and vivid pictures; but there's been a devaluation, too, because taking a good image is regarded by many people as being a case of pointing and clicking.

FINAL WORDS OF WISDOM: "If you find that you're becoming passionate about

taking pictures, make the time to learn the basic principles of photography and your images will improve as a result. Even if you continue to shoot on your camera phone, you will begin to notice a marked improvement once you understand what makes a good photograph."

☞ **WEBSITE:** www.leonneal.com
☞ **INSTAGRAM:** thetabascokid
☞ **TWITTER:** @tabascokid

Mark is a mobile photographer based mostly in London, UK.

NAME: Mark Simmons
LOCATION: London, UK
DEVICE: iPhone

Flickr is Mark's favorite social network: the community is encouraging and supportive, providing technical critique as well as praise that helps you to improve as a photographer. He loves social photography for its instantaneous nature. "We live in a time where we can see what is going on in real time by the images people are sharing and for something like street photography and photojournalism, that is exciting."

There are some drawbacks to the explosion in photo-sharing, though, Mark points out: "There are so many people publishing enormous volumes of images of food, of dogs, of their children, that it has all become a bit diluted and trying to find an amazing image on Flickr and Instagram is more and more difficult."

Mark uses Hipstamatic for 90% of his images: "The app's selection of simulated

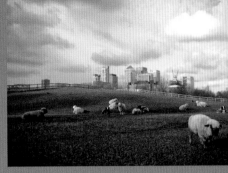

More Sheep Taking Over the City.

lens and film options are unrivalled in mobile photography and produce shots with great mood and atmosphere that can be very sharp indeed." He tries not to edit once it emerges from the Hipstamatic machine, but if a picture does need some more tweaking, he turns to Snapseed.

FINAL WORDS OF WISDOM: "Don't post everything you shoot. It might sound obvious but I have never seen a photographer post four or five shots a day on Flickr and not have some weaker images amongst them. Once a weak image makes its way into your stream, you lose the effect those really great ones can have."

The Blue Pill. Shot on London Bridge at the end of the working day, when everyone's heading in the same direction, across the bridge to the train station.

There Are Moments When We Are Ultimately Alone. For me, a great image captures something you can relate to, even if it makes you feel uncomfortable.

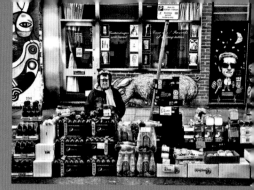

End of Season Sale. My aim was to capture what made the local markets of Shoreditch such an experience to visit, before the current trend of gentrification turns it into just another one of those markets that are open most days of the week, selling designer labels from boutique stores.

Although on first glance it appears quite humorous, there is, for me, a lot of sadness captured in this image. Like the last fragment of London watching the East End disappear.

Priorities. I knew this had to be black and white as soon as I saw the girl with her black dress and dyed blonde hair.

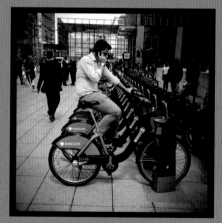

Downsized Workforce. A purely comic, candid moment, to me it spoke about the state of working lives in the UK.

FLICKR: www.flickr.com/photos/marktsimmons
TWITTER: @MarkTSimmons

Michael Sissons

Pigeons, Westminster Bridge. I was showing a friend around London and I spotted these pigeons. I must have been no more than one foot away when they decided to fly.

King's College London. When you're waiting for the bus, it's worth trying to make something out of the mundane. Nothing really worked until the chap on the left walked into the frame.

Michael is a solicitor based in South East London, but when he's not handling briefs, he's out with his iPhone, running Hipstamatic, and capturing London life.

NAME: Michael Sissons
LOCATION: London, UK
DEVICE: iPhone

Smartphones might have made photography more accessible, but it's also made it more disposable, which means that your images have to be

different to stand out and get noticed. That's where social networks come in for Michael: he uses them to gauge which of his photos people are responding to positively. They're also a means of directing eyeballs to his website where he showcases more of his work.

Being a Hipstamatic aficionado, Michael has some stellar advice for anyone who feels a bit overwhelmed by the combinations of lenses, films, and flashes that it presents you: "Don't get

![Ladybird on a car roof]

District Line. Some photographs quite obviously couldn't be taken with an SLR—at least, not by me. This was in high summer. Too much sun and alcohol, I think.

Oxford Circus Tube Station. I've tried to take this sort of photo again, but it never worked as well; sometimes I think it's better to capture things you haven't seen before rather than things you have.

Ladybird on a car roof. I took this wandering back from the shops one lunchtime in December. I wouldn't have caught it but for the camera on my phone. It was absolutely freezing, and I've no idea why the ladybird was out at all. It was moving very slowly, tracing its meanderings as it went.

blinded by all the different lens and film combinations because an unwise or random choice can ruin an otherwise good image. Have a look at Hipstamatic's Snap magazine, because it tells you what was used to take the photos and you can soon settle on a few that you like. Keep

the bells and whistles to a minimum and concentrate on the image."

FINAL WORDS OF WISDOM: "Just because a photograph looks like it's been processed in bleach doesn't make it a good photo."

CHOSEN COMBINATIONS
Color: Jane lens + Robusta, or Ina's 1969, or Blanko films
B&W: John S lens + A0 BW film
"I don't like to use many lens and film combinations because doing that can make your work look a bit of a jumble."

☛ **WEBSITE:** www.michaelsissons.com
☛ **FACEBOOK:** www.facebook.com/michaelsissonsphoto
☛ **FLICKR:** www.flickr.com/photos/michaelsissons/

Frozen Vanity

Sara, better known as Frozen Vanity, is a Muslim photographer who focuses her images on women and religion. As she puts it, she wants her photos to force viewers to question rather than see.

NAME: Sara aka Frozen Vanity
LOCATION: UK
DEVICE: iPhone

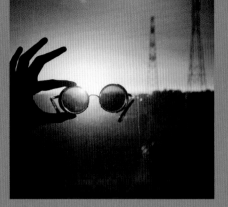

Instagram allows people a glimpse into Sara's daily life and interests; it's a very socially-oriented medium for her that isn't necessarily about sharing her best photos. Instead, it is about connecting with people through images. Her fashion and travel photography is reserved for her blog.

As well as sharing her own comings and goings through Instagram, Sara also used it to co-ordinate the See my Mosque project. The project had two aims: first to encourage young Muslim people to involve themselves with Islam in a fun and interactive way; second, to show people who aren't Muslim a side of Islam that isn't typically portrayed in the mainstream media. Members of the public are invited to take a photo of their

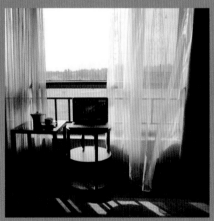

local mosque and upload it to Instagram with the hashtag #SeeMyMosque. You can look at a selection of the photos on the SeeMyMosque Tumblr.

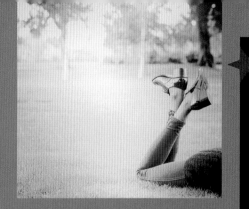

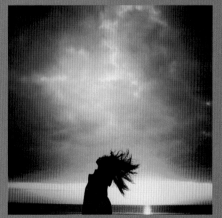

☞ **WEBSITE:** www.frozenvanity.com
☞ **INSTAGRAM:** frozenvanity
☞ **TWITTER:** @frozenvanity
☞ **BLOG:** www.frozenvanity.
blogspot.com

Filters aren't a faux-pas for Sara; they're tools to be used. Her favorites are Amaro and Mayfair. Sara's attitude towards phoneography is lighthearted: "The smartphone with a camera brought back the fun in taking photos without the need or worry of critical evaluation of the lighting, sharpness, or angle. Sometimes it is not all about the camera but it is how you improvise and try."

FINAL WORDS OF WISDOM: "Have fun and take photos of anything without worrying!"

Tana is based in Los Angeles and works in marketing; photography is her passion on the side.

NAME: Tana Gandhi
LOCATION: Los Angeles, USA
DEVICE: iPhone

Tana's diversified web presence is a great example of how to use different social networks for different purposes. She makes use of Facebook, Instagram, and Twitter, and she has her own website, too. Facebook is where she shares her landscapes and photos of her family and friends, but Instagram is the playground for her more conceptual work.

It's the simplicity of smartphone cameras that makes them great for experimental photography, and Tana thinks this is why so many people love to take photos with them. They don't require too much in the way of technical detail or gadgets.

Although she doesn't like to alter her images too much from the original, she doesn't shun filters entirely if they can enhance her work. Mostly she uses them to lighten her images. Tana's favorites are some of the VCSO Cam app's filters, as well as Rise, Valencia, and Mayfair for landscapes on Instagram.

FINAL WORDS OF WISDOM: "Experiment with different compositions and concepts using good lighting. It's probably one of the best and simplest ways to really enjoy photography."

☞ **WEBSITE:** www.tanagandhi.com
☞ **INSTAGRAM:** tanagandhi
☞ **TWITTER:** @tanagandhi

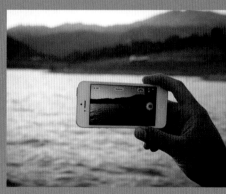

Meta-photography at Lake Casitas.

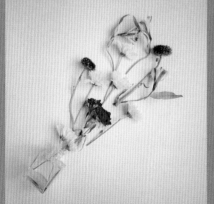

Prime spot if you want to feel short, at the Griffith Observatory.

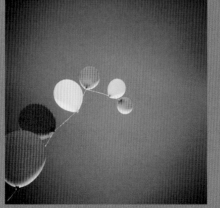

As with anything you want to improve in, practice is key.

Whoopsy Daisy.

Fun is just around the bend...

THINK ABOUT TANA'S USE OF *LINE* AND *color*

SQUARE-FORMAT SHOTS WORK WELL WITH CENTRALIZED SUBJECTS AND *diagonals*

COLOR CHOICE CAN MAKE A SIMPLE SUBJECT STAND OUT

Chapter 6

A smartphone camera in and of itself might not be the most sophisticated photo-taking device known to the human race, but it benefits from a killer attribute: the ability to augment it with apps. With a program here and a download there you can create composites, shoot long exposures, and share your creations beyond the usual social media suspects. Here are a few suggestions to get you started.

Further
App-field ▶▶▶

This view from Herne Hill, UK, is a lot wonky and a bit undefined. #LANDSCAPE

With a bit of help from Snapseed the horizon can be straightened and the definition improved. #SNAPSEED

Should the app market succumb to a peculiar monopolistic disaster that permitted users access to only one editing program, I would choose Snapseed without hesitation. It offers control, flexibility, and creative options in a clean user interface. It's my most-used app and while it is now free, I bought it when it wasn't. I don't regret a penny.

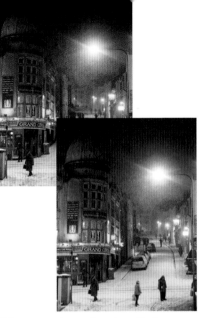

While street shots often benefit from a yellow color cast, in this case it was important to capture the crisp feeling of freshly fallen, pure-white snow. #NOYELLOWSNOW (© Frank Gallaugher)

Thankfully, we don't live in a world that's verging on a creative apocalypse, but if I were to list my other favorite apps that I think are worth a download, I'd name ColorTime for its extensive color manipulation capabilities and Pixlr-o-matic for fun and easy filtering.

Take one succulent growing in my aunt's garden. #CACTUS

Choose a film (in this case "Josh").

Add a lighting effect (this one is "Burn").

And you have a rather creepy plant! #PIXLROMATIC

Release your camera's shutter by making a noise with Triggertrap. #TRIGGERTRAP

Camera Settings

Self Timer **ON** 10 seconds

Burst Mode **ON** 3 shots
Takes photos in quick sucession

Anti-Shake **OFF**
Takes a photowhen camera is steady

Or you can set a more traditional timer with GorillaCam. #GORILLACAM

Aside from editing apps, Triggertrap and GorillaCam give you more control over how and when you can take photos with your smartphone. Triggertrap is geared more towards controlling a DSLR remotely, but it also has some useful smartphone features. Both it and GorillaCam are free, so you've nothing to lose!

Editing

Finding an editing app that suits you is a matter of trial and error. It needs to be the right combination of the tools that you want with an interface that appeals. There are hundreds of options out there, but here are a few to get you started:

AVIARY

In a world without Snapseed, I would probably rely on Aviary. It's a fuss-free and intuitive editing app. But it's the small details that I really appreciate. As soon as you open the app, the last image you took is waiting right there for your attention, or you can just scroll right and work through your image roll. You can rearrange the tool order so that your

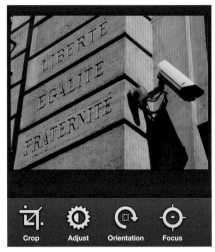

Pulling it into Aviary and cropping in tighter helps accent the subject. #AVIARY

There's graphic potential and a quality subject here, but it still needs a bit of work. #REVIEWING

And converting to B&W, plus a big contrast boost, pulls out the strong graphic qualities. #B&W (© Frank Gallaugher)

most-used functions are at the front of the queue. And it's well integrated with social networks and other apps that you might use, such as Dropbox.

PHOTOSHOP

Since Adobe leads the way in desktop image manipulation, you'd expect it to have at least one mobile editing app. It doesn't disappoint; it doesn't have just one mobile app, but two: the free Photoshop Express, and the all-singing all-dancing paid-for Photoshop Touch.

Unless you're desperate for the extensive Photoshop Touch editing prowess—it's a scaled-down version of the desktop program—Photoshop Express should meet all of your editing needs. You can crop, straighten, rotate, or flip your image; you can adjust the exposure, brightness and contrast, hue and saturation, and the tint and temperature; then you can convert to black and white or apply fun effects. For a small fee you can choose from even more effects and use the noise reduction tool; or you can let Photoshop make the adjustments for you. But where's the fun in that?

ALTERNATIVES?

If neither Aviary nor Photoshop floats your boat and you have an iPhone, you might want to look at Camera+, which gives you the tools to shoot in bursts and set a timer. It's not an app that I tend to use because it doesn't give me the control that I like over the editing process, but I know plenty of people for whom it's their go-to camera app. Or you could check out Filterstorm or Luminance. Android users might want to take a look at Camera Zoom FX as a solid editing application.

There are some paid features, like noise adjustment, but you also get a huge amount of editing options free with Photoshop Express. #PHOTOSHOP.

This adorable month-old kitten Cookie doesn't need much tweaking. #CUTE

Thankfully, it doesn't need much more than a crop and a little added contrast.

As you take more photos and share them more across the web, you might find that it's the photos that become important, rather than the networking. As you grow more interested in the photography, you may want to have a greater level of control than your phone's built-in camera can give you. There are plenty of apps on the market developed to meet the needs of serious phoneographers, with advanced features like histograms to help you perfect your exposure, a range of shutter speeds, and independent focus and exposure controls. Most of the apps featured below will also let you customize your hardware setup—meaning you can, for example, use the volume control for a shutter button, or to zoom, instead of the touchscreen of your phone.

At present there are few of this kind of app on the market for free, but some of the best ones cost hardly anything: between $1.99–$3.99 is fairly standard. Many of the paid-for camera apps also have free demo versions, so at least you can try it out first to see if you get along with the interface, and if you really need or want the controls it gives you. Here are a few of the best:

FOR IOS

1. For maximum quality and advanced control try PureShot. You can save your photos as uncompressed TIFF files, meaning you get a much finer level of detail than your standard JPEG file format. The drawback is a ginormous file size and slow sharing, but for some shots it may be worth it. As for control, you can customize your camera setup to the nth degree with manual focus and exposure, a choice of shutter speeds, and live histograms. PureShot markets itself as a #nofilter app, so you won't get any editing tools with it.

2. If you want a camera app that gives you plenty of control but also a good editing and effects toolbox, I recommend Camera+. Like PureShot you get to manually set your points of exposure and focus, and handily, you can turn on a "stabilize" mode so the camera takes the shot when your hand is stillest, helping to eliminate blur.

3. If it has to be free, try Camera Awesome. It's best known as being an extremely fast camera app, which is useful when it comes to capturing the

moment, but it also has tons of features, including the ability to manually set your points of exposure and focus.

FOR ANDROID

1. Of all the camera apps available for Android, Pro Capture is one of the best currently out there. It offers manual focus and exposure setting, composition aids, and a live histogram, as well as a number of different preset shooting modes.

2. While it lacks the manual focus and exposure options that experienced phoneographers may want for maximum creative control, Camera Zoom FX comes with a lot of extra features that make it one of the most popular camera apps currently available for Android, including scene modes for different types of shots—for example portrait, landscape, or action—stabilization, and white balance control. Unlike Pro Capture, Camera Zoom FX has some powerful post-processing tools, plus there's a variety of free add-on packs available if you want extra props and effects. Unfortunately the app itself isn't free.

3. With its camera-like interface and high level of control, Camera FV-5 might be slightly baffling if you're used to the simpler cameraphone controls, but once you start figuring things out you may come to love the huge range of functions and authentic camera feel. For your money (there's also a free version with limited resolution output) you get on-screen exposure compensation, a choice of different shutter speeds and settings (including, long exposure and time-lapse functions), live histograms, a variety of compositional grid overlays, and more.

Remember

Don't forget that as well as apps, there's a whole host of accessories available as seen in Chapter 4. It's hard to overstate what a difference these can make to your photography!

LEARNING FROM
communities

There are literally hundreds of online communities out there purely dedicated to photography. On these sites you'll often find industry news, product reviews, tips, techniques to try, photo challenges, and projects to inspire you—as well as forums where photo enthusiasts get together to ask questions, share thoughts and advice, discuss their favorite equipment, and so on. If you're getting serious about photography, these communities are excellent places to connect with photographers at every level and learn heaps of new things. For somewhere to start, I recommend photo.net and photocritic.org. And just for phoneographers, there's welovephoneography.com and phoneographyblog.com!

FILTERS

My original sunset shot.

And with FX Photo Studio's "Lemoore" filter in place. #LEMOORE

When it comes to adding filters to your images and playing around to give them different looks, Pixlr-o-matic has already had a look-in. But what about some of the myriad other options?

FOR IOS

FX Photo Studio is a filtering powerhouse on the iOS platform. It has close to 200 filters—from artsy brush-strokes effects to vintage tones, via grungey looks and a selection of textures—that you can apply and blend, giving you an incredible number of options.

It allows you to adjust color saturation, contrast, and exposure, add signatures or watermarks, fiddle almost infinitely with

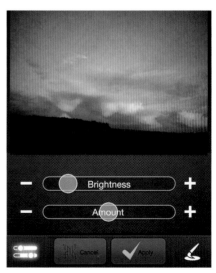

With the "Vintage" filter applied.

your color mixes, and rather importantly, share directly with your social networks. As an added bonus, it gives you a fun fact to read while it is processing your image.

FOR ANDROID

Photo Studio is the Android option if you want more filters than you can shake a stick at, special effects galore, enough color tweakage to make Picasso wince, as well as the normal crop, contrast, and saturation operations.

ALTERNATIVES?

Android users can take a look at PicsPlay Pro, PicsArt, or Pixlr Express for their filtering delight; they're only a taste of what's available, both paid-for and for free. If you use an iPhone, you might want to look at Scratchcam or Plastic Bullet for fun and easy filters.

The original shot. (© Rachel Silverlight)

Final image with the "Summer Air" filter applied. #SUMMERAIR

Photo Studio has a useful Filter Mask function that allows you to easily apply a filter to just one part of an image.

FIRST YOU NEED TO

visualize

It's so easy to overuse filters when you're confronted with all that choice! Just as when you're taking the original photo, try to visualize the look and effect you want to achieve before going filter crazy. Sometimes you want to make a statement with a bold filter, but don't forget to let your photography speak for itself.

LAYERING & compositing

Creating complicated layered and delicately composited images might once have been the preserve of photographers and digital artists prepared to spend hours poring over their computer screens beholden to immensely powerful editing programs, but not any more. With a bit of vision and a healthy dose of patience, it's perfectly possible to create composites using your smartphone.

JUXTAPOSER

Juxtaposer is my go-to iOS app for layering images. It lets you create a montage by sticking bits from one photo on top of another. You work with two images: a base image and an upper image. Using your fingers to resize, rotate, and erase, you remove parts of the upper image to reveal the lower picture and create a composite.

When you're finished with the first two layers, you can share it with your social networks, or import a third layer and keep on compositing.

Don't worry if you can't complete your composite in one sitting: you can always save and resume.

Why I'd want to make myself emerge from a kettle is anyone's guess, but I can with Juxtaposer. #JUXTAPOSER #SURREAL

IMAGE BLENDER

At its simplest, Image Blender allows you to blend two images and decide which image is the stronger element in the blend. You can choose from 18 different blend modes to decide the look of the combination. It's great for creating a double-exposure effect. Alternatively, you can create a montage by layering one image over another, moving, rotating, and resizing the upper image, and then erasing its extraneous data to reveal the lower image and create a composite.

Like Juxtaposer, you can add a third layer when you've merged layers one and two, and it has a copy-and-paste option, too.

CUTOUTCAM PRO

CutoutCam Pro is an Android-compatible compositing app. Instead of erasing the superfluous data from one image to reveal another, you cut a hole in the base image and insert a second photo into it.

ALTERNATIVES?

If you don't fancy Juxtaposer, Image Blender, or CutoutCam Pro, you can look at Superimpose for iOS or PicSay Pro if you have an Android smartphone.

DOUBLE EXPOSURES

A fun, artistic effect that is really easy to do on a smartphone is the double exposure: the combination of two photographs into one. Editing apps such as Photo 360 and Vignette come with multiple exposure functions to play with, and there are several dedicated multiple exposure apps on the market as well.

When it comes to double exposures you do need to think a bit about your composition: any two randomly chosen images mashed together won't necessarily work (although they might). Bright colors and abstracts combined with a stronger form, for example writing, a portrait, or a silhouette, can look great. If you have a stabilization device, try taking two shots, one with a person in it and one without, and combining for a ghostly effect. There are no set rules here, so experiment to find out what works!

Strong silhouetted forms often work well in a double exposure. #DOUBLEEXPOSURE

LONG EXPOSURES

Long exposure isn't just about capturing a photo when the light is dim and you need to grab as many photons as possible to create an image. It's also a gorgeous technique to put a sense of motion and flow into your pictures, too; think tumbling waterfalls or light trails from cars.

There's no shortage of apps that can help you to set long exposure times or combine multiple exposures to get the most out of the light. Android users might want to look at LE Cam Free first, seeing as it's free. However, for more control, there's Camera FV-5, which we looked at earlier in the chapter. It does a lot more than allowing you to control the length of your exposures.

Barring the unwieldy name, I've good experiences with Slow Camera Shutter Plus Pro Free for iOS. It's free; it provides a selection of exposure times (0.5 second, 1, 2, 4, 8, 15 seconds, and bulb mode); it has automatic, manual, and light trail modes; and you can share your images straight to Facebook or Twitter, or send them via email.

Should the free apps not work out for you, there are paid-for iOS long exposure apps as well. Take a look at Slow Shutter Cam, LongExpo, and Slow Shutter.

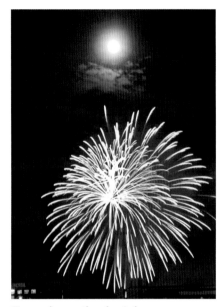

Fireworks are the classic long-exposure shot, but you've got to find a way to hold your phone still for the duration of the exposure. #4THOFJULY (© Frank Gallaugher)

Creative long exposures are all about embracing movement. That same movement that can make your photos look blurry is now going to be the key ingredient in creating spectacular images. The difference is control. When your shutter's open for a long time, the slightest shake can ruin a photo, so now is the time to be getting out that tripod and, for maximum control, a remote shutter release. Compose your photo, set the length of the exposure, and see what you achieve. A long exposure will be necessary for low-light and night photography, but you can also try using it on moving subjects during the day.

Alternatively, try creating long exposures with a moving camera. This can be great for making abstracts, whether you're focusing on a fixed subject or going freestyle with a little "camera tossing." Camera tossing is very much what it says on the tin—you release the shutter and throw your phone in the air (remembering to catch it again, of course). If you want to give it a go, I recommend you try it out on a soft surface first!

TIME LAPSE

If you've ever watched a nature documentary and seen a plant's weeks-long life-cycle play out on your screen in a matter of seconds, that's time-lapse photography. Time-lapse photography takes a series of images filmed over an extended period of time and plays them back in a condensed period of time.

It's a great way of documenting change in photographic format, whether it's clouds rolling by or a pregnant woman's expanding belly. If you don't mind anchoring your phone to a tripod for the duration, creating a time-lapse video is probably easiest using an app such as Lapse It. When you've identified your scene, set up your smartphone on a tripod and select how many photos you want to take over a given period of time. Hit "go" and Lapse It does the rest, triggering the shutter at your designated intervals and compiling the resulting photos into a video. Just don't forget to plug your phone into a charger if it's going to be a long one!

Dramatic clouds passing overhead is a classic subject for time-lapse photography. #TIMELAPSE #LAPSEIT

Removals

Every now and again you'll take a photo where a pesky telegraph wire is cutting across your vista or someone has a grim, pustular protrusion from her or his chin that is unattractive, distracting, and isn't normally there. Do not lose hope! Download Touch Retouch for free and you can embark on an easy image salvage process.

I like this photo of a disused tap, pouring forth spider's webs instead of water, but there's a rather irritating telegraph wire ruining the perfect blue sky.

PAINTING
faces

It's just as easy to paint over spots and blemishes on your portraits and selfies with Touch Retouch before you share with the world!

1. Double-tap to zoom in on your image then select the brush option from the bottom panel and adjust the size of the brush accordingly. Ideally, you want the brush to be as small as feasibly possible.

2. Carefully trace the path of the unwanted material, in this case the telegraph wire. It will be highlighted in red. (You can change this color if you need to, say if your image is also red.)

3. Hit "Start" and Touch Retouch will work its algorithmic magic to remove the imposter.

4. You can now save your re-worked image to your camera roll, email it to someone, send it to another app for further editing, or share it straight to Facebook, Flickr, or Twitter.

Et voila!

How much better is that?
#TOUCHRETOUCH #ERASER

There is also the choice to lasso a selection, rather than draw over it with a brush, or to replace one part of an image with another using the clone stamp.

KEEPING YOUR *pictures* SAFE

If you were to drop your phone in a puddle or it were to be pick-pocketed by some unscrupulous toe-rag, what would become of all your photos? Some of them might be stored safely in the cloud (if you'd shared them on Flickr, for example) but the others, not so much. Unless you have a back-up plan in place, they'll be gone for good.

The golden rule for preserving digital data is that it needs to be stored in a minimum of two different places, and preferably in different formats. You can probably imagine that as someone whose life revolves around words and pictures, I have a fairly extensive back-up strategy in place. It involves a rotating pair of off-site hard drives, two cloud storage facilities, and the rather archaic option of printing my photos!

If you have an iPhone, chances are your photos are being backed-up to the iCloud automatically. However, whatever device you use, I would recommend subscribing to a cloud storage option, downloading its app to your phone, and then regularly backing up your photos from your phone to the cloud.

There are lots of options out there and as the cloud gathers, more and more are springing up. I would start by looking at Dropbox; the biggest name in cloud storage. It offers 2GB free storage, which can be increased to a maximum of 18GB by inviting friends and completing steps in the installation process. Box offers 5GB of storage for free and so does Jottacloud. Copy provides a whopping 15GB of free space before you need to upgrade. But it's always worth shopping

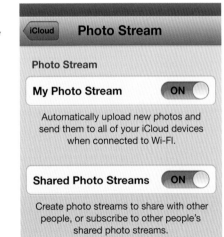

You can automatically back up your iPhone images to the iCloud. #ICLOUD

around for special offers or asking friends if they have any referral codes.

Instagram's stratospheric rise has encouraged an eco-system of add-ons and accessories to grow up around it. This includes Instagram print options from established companies such as Metroprint and Photobox, which will also print your not-Instagram photos (take a look at Postalpix for that, too), to those dedicated to the Instagram phenomenon, such as Printstagram, Origrami (yes,

spelled with a second "r"), and Instaprint. These guys won't just print your photos, but they'll create calendars, books, stickers, and posters, too. In fact, almost anything that can be done with an image, they'll manage it.

Finally, you can always indulge in some old-school networking and send your photos as postcards. Apps from Touchnote or Postagram will let you send a postcard straight from you smartphone. New world meets old school!

You can forget about people wanting to steal your images with a watermark as ugly and obtrusive as this. They won't even want to look at them!

This watermark's subtlety makes it unobtrusive and its placement makes it difficult to remove digitally.

Glossary

APERTURE The opening behind the lens through which light passes to reach a camera's sensor.

APP Short for "application," a specialized program that you run on your computer, tablet, or smartphone.

ASPECT RATIO The relative size of an image, with width compared to height (e.g. 4:3, or 1:1 for a square).

BULB Shutter speed setting that allows you to keep the shutter open indefinitely. Used for creative long exposures.

CLOUD The connection of many electronic devices to share and store digital data.

COLOR CAST An unwanted tint to your photo, often found when shooting in challenging light conditions, such as under fluorescent light.

COLOR TEMPERATURE A way of describing the color differences in light, measured in degrees Kelvin and using a scale that ranges from red (1900K), through orange, to yellow, white, and blue (10,000K).

CONTRAST The range of tones across an image, from highlights to dark shadows.

CROPPING The process of removing unwanted areas of an image.

CROSS-PROCESSING The act of processing one type of photographic film in chemicals intended for a different type of film.

FILTER Traditionally, an accessory placed over a camera's lens that alters the quality of the light; now it's also a digital process used to add effects to an image.

FOCAL LENGTH The distance from the optical center of a lens to the sensor. Usually measured in millimeters.

GOLDEN HOUR The period around sunrise and sunset when light is soft and golden and particularly good for photography.

HASHTAG # A means of categorizing and labeling posts made to social networks.

KEY The range of tones or brightness in an image; low-key images tend to be dark and shadowy, while high-key images are light and bright.

LENS FLARE Bright streaks seen in images that are caused by aberrant rays of light hitting a camera's sensor.

LICENSE An agreement made between a photographer and another party that allows the other party to use a photographer's image.

MICROBLOG Brief updates shared across the internet, for example posts made to Twitter or status updates on Facebook.

NOISE Random pattern of small spots on a digital image, caused by non image-forming electrical signals. Often found when shooting in low light.

RESOLUTION The level of detail in a digital image, measured in pixels (e.g. 1024 by 768 pixels).

RULE OF THIRDS A common photographic rule that divides the frame into nine equal spaces to aid with composition.

SHUTTER SPEED The length of time a camera's sensor is exposed to light.

SMARTPHONE A multi-functional mobile phone that's closer to a pocket-sized computer than a telephone.

SOCIAL NETWORK The people with whom you interact and have relationships; now communication often takes place through dedicated apps and websites across a variety of media.

TELEPHOTO A lens with a long focal length (typically in excess of 70mm) that allows you to get closer to your subject.

TERMS OF SERVICE/TERMS OF USE/TERMS AND CONDITIONS An agreement between a supplier (e.g. a social networking platform) and an individual that sets out the parameters of the service offered, appropriate behavior, and mutual expectations. Also serves as a disclaimer.

USER GENERATED CONTENT Text, images, and videos that users upload to websites to be shared and disseminated.

WEB 2.0 The advancement in websites that moved them on from static pages to interactive and collaborative content.

WHITE BALANCE The differing rendition of colors in an image depending on the temperature of the light when it was shot.

WIDE ANGLE A lens with a shorter focal length (typically less than 35mm) that produces wide, sweeping images.

Index

Acknowledgments

As much as writing is a solitary activity,
no book is ever produced in splendid isolation.
To that end I would like to thank the Ilex team: Adam
Juniper and Roly Allen for offering the book to me;
Natalia Price-Cabrera for managing the editing process;
and Kate Haynes for creating such a gorgeous looking
thing. In particular, my thanks go to Rachel Silverlight for
her unflappability at the most flappable of moments.

My family and friends must contend with me
as either a hermit or a demonic camera-wielder
throughout the writing process. I thank them
for their patience and their support.

FOR HJK

Photographs on page 2 (L–R):
First Row: Allison Smith; Darren Shilson; Darren Shilson; Mark Simmons; Michael Coutinho.
Second Row: Sara (Frozen Vanity); Michael Sissons; Isabel Malynicz; Michael Sissons; Leon Neal.
Third Row: Allison Smith; Isabel Malynicz; Michael Sissons; Tana Gandhi; Mark Simmons.
Fourth Row: Isabel Malynicz; Darren Shilson; Sara (Frozen Vanity); Bruno Coutinho; Bruno Coutinho.

All photographs are © Daniela Bowker unless otherwise indicated.

FINALLY
TO EVERYONE
WHO CONTRIBUTED TO
THIS BOOK

IT'S ABOUT
**SOCIAL
PHOTOGRAPHY**
AND YOU
HAVE HELPED MAKE IT

infinitely

MORE SOCIAL

I AM
forever
GRATEFUL